IMAGES
of America

BOSTON
PUBLIC LIBRARY

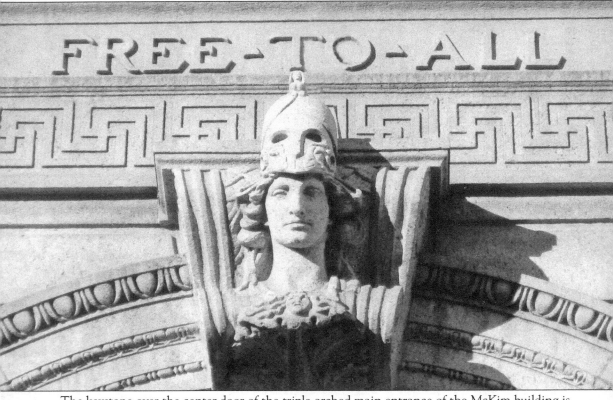

The keystone over the center door of the triple-arched main entrance of the McKim building is the helmeted head of Minerva, the Roman goddess of wisdom. This figure was carved in granite by Augustus Saint-Gaudens and Domingo Mora. The notable inscription "Free to All" is taken from a letter from Joshua Bates to Mayor Benjamin Seaver, dated October 1, 1852, in which Bates offered to donate $50,000 toward the purchase of books as long as the city provided the building and paid the expenses. Bates said in part, "The only condition that I ask is . . . that it shall be perfectly free to all." (Photograph by Catherine Willis.)

ON THE COVER: The front entrance to the Boston Public Library's McKim building was used as a gathering place and a photographic backdrop for many groups. Pictured here is Boston's former mayor, Hugh O'Brien, in the center of a large group of people. Note that even with all the people posing for the photograph, there is a maintenance man on a ladder changing a light bulb in the lantern to the right of the center door. (Courtesy Boston Public Library.)

IMAGES
of America

BOSTON
PUBLIC LIBRARY

Catherine J. Willis
Foreword by Amy E. Ryan

ARCADIA
PUBLISHING

Copyright © 2011 by Catherine J. Willis
ISBN 978-1-5316-4952-4

Published by Arcadia Publishing
Charleston, South Carolina

Library of Congress Control Number: 2010939566

For all general information, please contact Arcadia Publishing:
Telephone 843-853-2070
Fax 843-853-0044
E-mail sales@arcadiapublishing.com
For customer service and orders:
Toll-Free 1-888-313-2665

Visit us on the Internet at www.arcadiapublishing.com

To my Dad, who taught me to see that the glass is half full

CONTENTS

FOREWORD

When I was selected as the first woman president of the Boston Public Library in 2008, it was a librarian's dream come true. The Boston Public Library is among the great research libraries of the world. In addition to books, it encompasses photographs, drawings, maps, musical scores, and countless other rare and valuable treasures. The library is truly the intellectual heart of Boston and steward of our cultural heritage.

Thanks to the vision and generosity of the citizens of Boston, it remains—in the words of the inscription carved in stone above the front entrance to the McKim Building in Copley Square—"Free to All."

Catherine Willis's book takes us back to 1852 when Boston led the nation in establishing the first large municipally funded public library. The Boston Public Library of yesterday was a cultural guardian, acquiring and safeguarding unique and distinctive collections for generations to come. Now, our collection numbers over 22 million items, making it an unparalleled resource for researchers, lifelong learners, and the intellectually curious.

Today's library is a vibrant, service-oriented institution with a central library in Copley Square and branches throughout the city. People of all ages and from all walks of life flock to Boston's libraries to enjoy educational programs, family entertainment, homework assistance, and access to online resources and digitized collections.

Building on our legacy, the Boston Public Library continues to be a leader in public library service. From fairy tales to downloadable media, our libraries are cultural anchors, community centers, and centers of knowledge. In the spirit of the founding trustees, it is our responsibility to ensure that the Boston Public Library continues to be an innovative and exciting place for all of us today and for our children and grandchildren tomorrow.

The images in this book reveal the rich history and unique nature of this institution. I invite you to explore this story and to allow these images to remind you of our past, illustrate the present, and illuminate the future.

—Amy E. Ryan
President of the Boston Public Library

ACKNOWLEDGMENTS

Though the act of writing is solitary work, authors do not work alone, and this book is certainly the product of many people.

I am very indebted to my friends and colleagues at the Boston Public Library for their feedback and encouragement. I would like to specifically mention Aaron Schmidt, who helped me immensely with the task of discovering the many images in the library's collections. The assistance of the digital services department—Thomas Blake, Christine Watkins Rissmeyer, Anna Fahey-Flynn, and Danny Pucci—has been invaluable to me. Bahadir Kavlakli's work in the digital lab was outstanding, and his sense of composition was always spot on. Sean Casey, from the rare books and manuscripts department, assisted me greatly as I poured through the library's archival records. I feel a very deep sense of gratitude to Nancy Browne, who gave me the peace of mind to focus on the book, the encouragement to keep going, and for all her many excellent editorial suggestions. I also want to thank Marta Pardee-King for her patience and support. She helped me believe a book like this would find readers. Many other library staff have assisted and encouraged me in this project, including Elizabeth Prindle, Henry Scannell, Gina Perille, Mary Frances O'Brien, Ruth Kowal, Christine Schonhart, John Dorsey, James Meade, Scot Colford, Kimberly Reynolds, Janet Buda, Anne Smart, Frances Francis, Rebecca Manos, and of course, Amy Ryan. They have all given extremely valuable help to me on a timely basis.

I was very fortunate to talk to library trustee James Carroll, who inspired me and spurred me on just days before my deadline.

I am most grateful for the inspiration and wisdom of my friends Margot and Jack Sullivan.

And last, but certainly not least, thanks go my sisters Teresa Beaudoin, Patricia Daniels, Carol Vasche, and Mary Swaving for their constant effort to keep me focused and on track and for being there whenever I needed them.

Unless otherwise noted, all images appear courtesy of the Boston Public Library.

INTRODUCTION

The Boston Public Library was the first large municipally funded public library in the United States. Although the library was officially founded in 1852, the original idea was first proposed by the French ventriloquist M. Nicholas Marie Alexandre Vattemare in 1839 when he conceived the idea of an exchange of books and prints between French and American libraries. The original project failed, but in November 1843, Mayor Martin Brimmer accepted 50 volumes from Vattemare that were deposited at the mayor's office in city hall. Another donation from the people of Paris was received by Mayor Josiah Quincy Jr. in 1847, making a total collection of 96 books, maps, and engravings. No persons, except for those officially engaged at the city hall, were allowed to borrow any of the items.

Between 1841 and 1851, various attempts to establish a free public library in Boston were made. Sums of money were conditionally offered, and an attempt was made to partner with the Boston Athenaeum. American politician, diplomat, and educator Edward Everett donated his large collection of United States public documents to the city for use in the public library. Edward Everett was the first president of the board, and he and his successor, George Ticknor, were the prime movers in the establishment of the Boston Public Library.

Boston-born Joshua Bates, of the Baring Brothers Bank of London, read the first report from the board of trustees and was moved to donate $50,000 towards the establishment of the public library. He had only three conditions. The first was that the city of Boston would provide a building that would be an "ornament to the city." The second condition was that the city would pay all the expenses of running the library. And the third condition was that the library would be free to all. Soon after he presented this first gift, he donated another $50,000, specifically to be used for the purchase of books.

The first library was officially opened to the public in just two small rooms in the Adams School on Mason Street in March 1854. For the first time, all Bostonians "of respectable character" who were older than 16 and who had a personal reference from a citizen had access to any of the 5,000 books and periodicals in the building and had the privilege of taking any one book home for two weeks. Unfortunately, the library building on Mason Street was very small, poorly ventilated, noisy, and not well lighted. Soon after it opened, plans for the construction of a larger building began, and the design proposed by Charles K. Kirby was selected.

Property on Boylston Street, across the street from the Boston Common, was secured and the cornerstone was laid in 1855. In 1858, the building at 55 Boylston Street was completed at a cost of $365,000 and opened with 70,000 volumes. It was made of red brick and had sandstone trimmings, two soaring stories, and a basement. On the top floor was Bates Hall, where most of the books were stored in 60 alcoves and six galleries. Bates Hall was the principal room in the building and was used for reading and reference work. On the first floor was the book delivery room, the circulating library room, and two reading rooms, the smaller one reserved exclusively for women. The circulating library room contained popular fiction and nonfiction books and all the

children's materials. The periodical reading room in the basement held all the leading periodicals and newspapers of the United States and Europe. The bindery was also in the basement and was where the books were bound and repaired.

Just 20 years later, the library had outgrown the Boylston Street building, and the trustees asked the state legislature for a plot in the newly filled Back Bay. On April 22, 1880, the state granted the city of Boston a lot situated on the corner of Dartmouth and Boylston Streets. The first steps had been taken towards the construction of a new library building.

Charles Follen McKim of the New York firm of McKim, Mead, and White, was appointed the principle architect of the new building in 1887, but he was not the first to take a shot at designing the new library. In 1884, a competition was held, and although prizes ranging from $1,000 to $4,000 were awarded, the city council determined that the library board of trustees had no authority to make the award, and none of the 20 plans was determined suitable. Two city architects, first George Clough and then his successor, Arthur Vinal, were asked to draw up plans. Although Clough never got past the drawing board, the trustees were forced to move ahead under Vinal's plan. The trustees faced a deadline of April 21, 1886, to begin construction or the lease of the library site would revert to the commonwealth. At 4:18 p.m. on the 21st, the first pile was pounded into the Back Bay landfill. By the end of the year, almost $75,000 was expended on pilings and a foundation. Unfortunately, Vinal's plan had to be abandoned because it was determined to be unfeasible. The construction was halted.

Ultimately, Mayor Hugh O'Brien authorized the trustees and the city architect to jointly award the contract and supervise construction, and in 1888, without any further competition, they awarded the contract to McKim, Mead, and White. When McKim started the project, he was put in the impossible position of having to "build on the foundations of another man," but was ultimately cleared to start from scratch, forcing the trustees to pay to remove that part of the existing foundation that could not be adapted to the new plan.

Samuel A.B. Abbott, president of the trustees from 1888 to 1895, was the driving force behind the construction of the new building. He pushed for the selection of McKim as architect and kept his hand in every stage of the building process. Abbott had a hard time delegating authority and was justly accused of autocratic methods; he did not even seek advice from the librarians. But without his will, guidance, and belief that Boston's library should be more than just a book repository, Boston would have ended up with a far inferior building.

There was much opposition to the design of the building, most notably from Dr. William F. Poole, a leader in the movement for practical utility and convenience in library buildings. The McKim building was designed for the scholar rather than for the general reader and as an elegant monument rather than as a functional library building.

Poole vehemently opposed the closed stack system and advocated for the free and easy access to books on open stacks in a series of reading rooms, each devoted to a specific subject. Poole's plan had such a nice logic of organization, it is no surprise that it was the favorite plan of most librarians. However, in reality, the plan required too much duplication of staff and too much space to be practical, and it did not take into account that research often leads people through more than one subject area.

If the biggest defect of the central stack system is the physical separation of the books from the public areas, that defect was exaggerated in the Boston Public Library. Because fire tends to travel in a straight line, McKim had the stacks placed off level from the public areas of the building as a fireproofing measure. The unfortunate side effect of this precaution was that the moving of books efficiently from the stacks to the public area is very difficult.

Another controversy over the building was the library seal that was carved by the American sculptor Augustus Saint-Gaudens and placed over the entrance door. After the seal was revealed, it caused a scandal in the local newspapers because two nude boys flanked the shield in the center of the seal. The headline in the *Boston Evening Record* of February 10, 1894, screamed: "Wipe Out the Blot." Suggestions for correcting this indecency ranged from gentle (the carving of fig leaves) to humorous (dressing the boys in short pants) to violent (castration by chisel).

The McKim building, especially the Dartmouth Street facade, dramatically changed Copley Square. While the old Boylston Street building held 450,000 volumes, the impressive McKim building was designed to hold two million books. It was originally expected to cost $1,165,955; the actual cost was over $2,368,000.

The Boston Public Library was the first public library in the nation to open a branch. However, not all the remote locations actually began as branches. Some were originally "delivery stations," which were usually one or two tiny rooms in a rented storefront. Since very few books were actually shelved in these delivery stations, patrons needed to refer to the catalog to find the book they wanted and request it from the central library or one of the neighboring branches. Some of the early locations were reading rooms, founded because of gifts from local clubs and associations. These locations had small collections that were available to check out, but they also relied upon deliveries from the central library. Some locations were "full" branch libraries from the beginning. Many delivery stations and some reading rooms were established and existed for a few years, only to be discontinued or replaced by others. The system grew quickly after the East Boston Branch Library first opened in 1871. The library also added several branches when nearby cities and towns were annexed to the city of Boston. Over the years, there have been 43 named branches, reading rooms, and delivery stations at 125 different addresses.

As early as the 1950s, the McKim building was obviously too small, and plans were started for a major addition. In 1972, the size of the central library was doubled when the new Philip Johnson building was constructed adjacent to the McKim building along Boylston Street.

In 1852, Boston pioneered an institution that today is accepted as an indispensable part of every community. A great public library is a far more complex institution than appears to a casual visitor or even a frequent user. It is more than just a collection of books. It is really an organized concentration of knowledge recorded in a variety of formats (books, periodicals, manuscripts, films, sound recordings, photographs, music scores, maps, etc.) whose usefulness depends as much on ready availability to the reader as upon its extent and comprehensiveness.

Not only is the Boston Public Library free to all, more than any other Boston institution, it is used by all. No other establishment has so great a place in the lives of so many citizens from so many walks of life or of such diversities of age, economic status, race, and creed.

One

THE EARLY YEARS

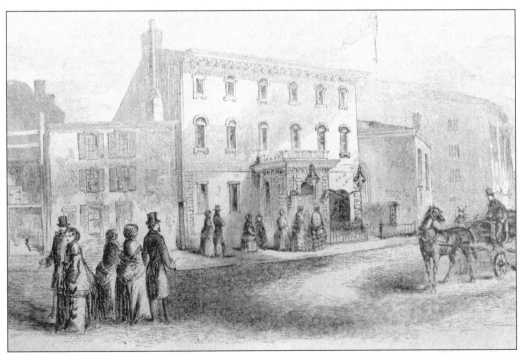

On March 20, 1854, the Boston Public Library was opened on Mason Street in two rooms on the ground floor of the Adams School, which was the Girl's High and Normal School. All Bostonians "of respectable character" who were older than 16 had access to any of the 5,000 books and periodicals in the building and could take any single volume home for two weeks. After just six months, 6,590 people became members of the library and 35,389 items were borrowed.

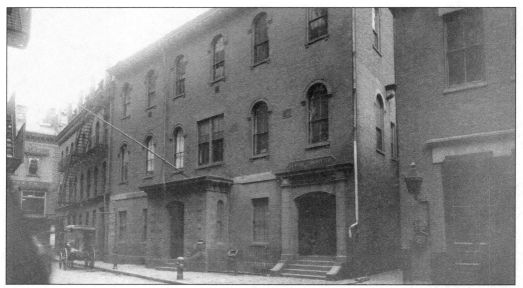

Before the doors on Mason Street even opened to the public, the trustees knew the space would not be large enough. The rooms were also found to be ill-ventilated, noisy, poorly lighted, uncomfortable, and generally unfit as a place for quiet reading. The collection grew so quickly that two additional storerooms were secured on the upper floor for an additional 6,000 books. By December 1854, the city commissioners authorized the library trustees to purchase property on Boylston Street for a new building. At the time this photograph was taken, the library had moved to the new building on Boylston Street, and this structure was used as the headquarters of the Boston School Committee.

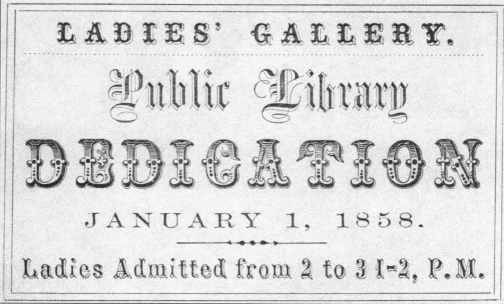

LADIES' GALLERY.

Public Library

DEDICATION

JANUARY 1, 1858.

Ladies Admitted from 2 to 3 1-2, P.M.

Times were different for women when the new building at 55 Boylston Street was dedicated on January 1, 1858. This special ticket admitted a woman to the ceremony, but only to the ladies' gallery.

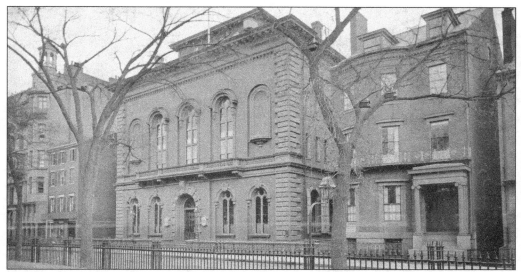

A total of 24 designs for the new building were submitted. Ultimately, the plan by Charles Kirk Kirby was selected. The requirements for the building were brief and contained general statements, including the following: the capacity to shelve 200,000 volumes, a general reading room with seating and tables for 150 readers, a ladies' reading room with seating 50, an adjacent room for the 20,000 books "most constantly demanded for circulation," rooms for the trustees and librarian, a facade made with brick and stone, and it must be absolutely fireproof.

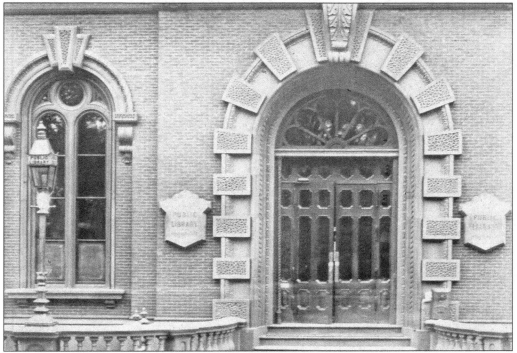

The beautiful glass-paneled main entrance door on the red brick and Connecticut sandstone building had a deeply molded and carved jamb, a vermiculated archivolt, a projecting canopy, and was crowned with a keystone, all of which were ornately carved.

13

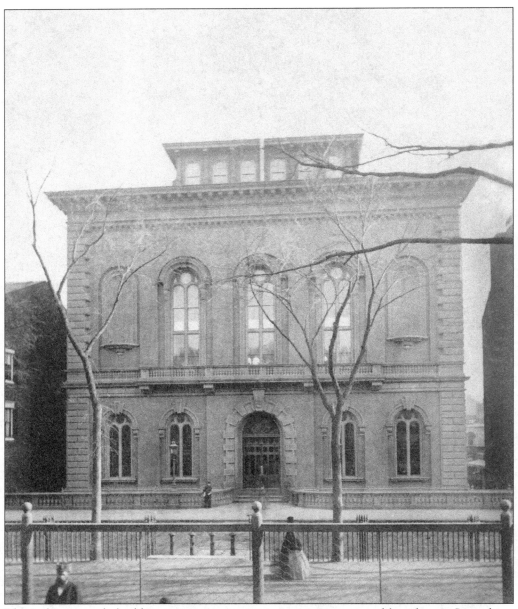

The Italianate-style building was an impressive structure surmounted by a heavy Corinthian cornice. The total cost, including land, was $364,000. This was Boston's first municipal building designed exclusively for use as a public library. It was located on Boylston Street directly across from the Boston Common on what is now the site of the present Colonial Theater. Once the library vacated the building, it was leased to the Bowdoin Square Theater, which was a concert hall and beer garden.

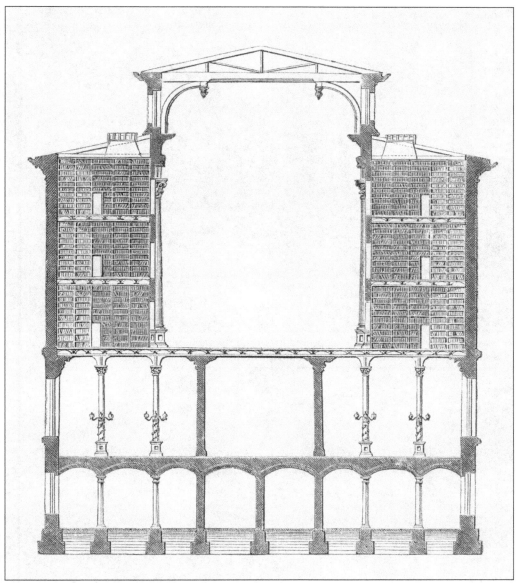

This cross-section view of the library on Boylston Street clearly shows the three floors of alcoves on each side of the Bates Hall main reading room. The floor below the great hall included a general reading room, a special reading room, the closed stacks holding the popular fiction and nonfiction books, and the delivery room, where people went to request and pick up the books they wished to take home. The lowest level on this plan was below street level and contained additional shelving, public meeting rooms, staff workrooms, and the janitor's living quarters.

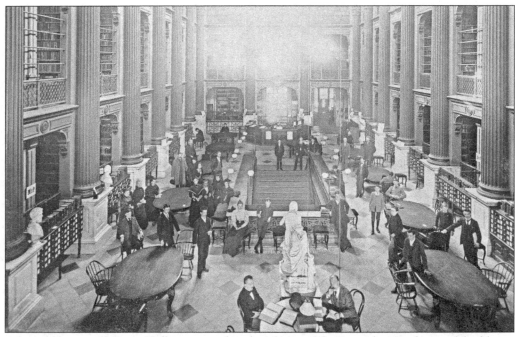

A busy afternoon in Bates Hall is captured in this photograph. Since the popularity of the library was so great, the building was open from 9:00 a.m. to 9:30 p.m. Monday through Saturday.

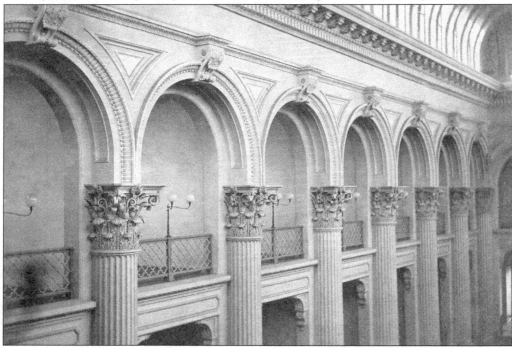

Corinthian columns and capitals supported the arches surrounding Bates Hall. The skylight was 90 feet long, and the clerestory windows above the alcoves were 10 feet high. The shelves in the alcoves behind the columns had not yet been installed.

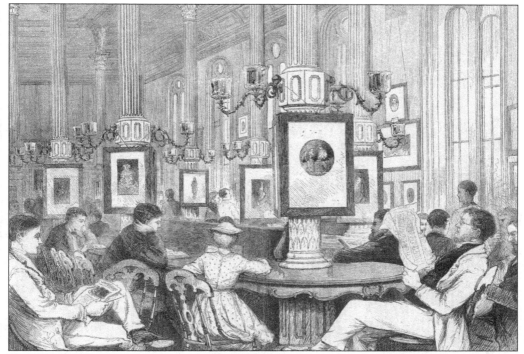

By January 1871, when this etching was created, there was no longer a separate reading room for women. As was the custom of the day, the walls and pillars in the reading room on the first floor were used to display many works of art.

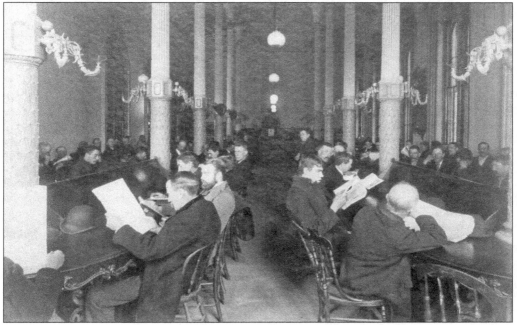

This photograph is of the same reading room that is depicted in the etching above. Although there seemed to be plenty of gas lighting, the 21-foot-high room was notoriously dark.

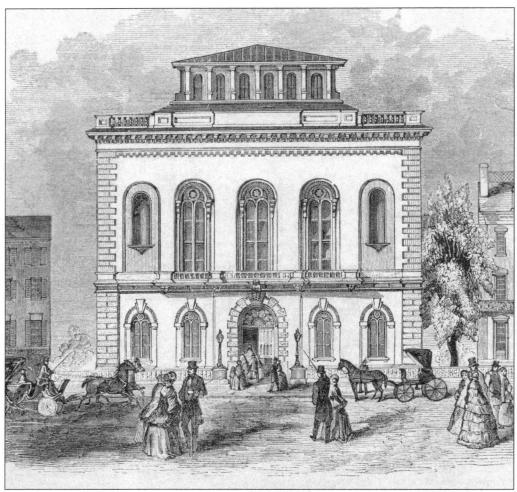

The ceremony of laying the cornerstone was performed on September 17, 1855, which was the 225th anniversary of the day Trimountain was renamed Boston. The box deposited under the cornerstone contained the following articles: a crystallotype likeness of the commissioners; crystallotypes of the trustees of the library, the mayor, the chairman of the committee of arrangements, the board of aldermen, and common council; silver and copper coins of 1855; four medals of the Humane Society of Massachusetts; city documents relating to the library; a Boston directory; a catalog of the library; order of exercises connected with the laying of the stone; and a lovely silver plate. A separate lead box containing copies of the 70 weekly and daily newspapers published in Boston was also deposited in the cornerstone.

Materials were moved from Mason Street to Boylston Street between June 30 and September 17, 1858. Here are the books as they were being sorted onto the shelves in the alcoves of the circulating library room on the first floor. In the three years since the library opened on Mason Street, 48,234 additional books were either purchased or donated to the library. The library's major benefactor, Joshua Bates, donated another 26,618 items during the same period.

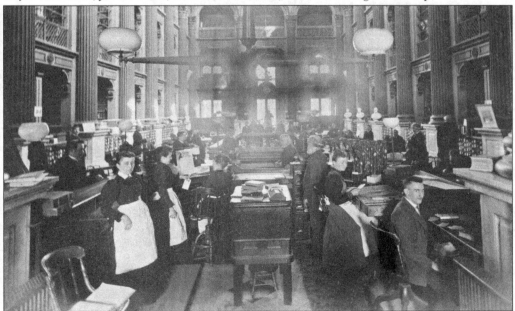

This interior shot of Bates Hall shows all the female librarians wearing plain dark dresses and white aprons. On both sides of the hall are the card catalogs, first introduced in 1871. This great hall was 58 feet high, and the clerestory windows along all four sides of the building provided natural light to the readers.

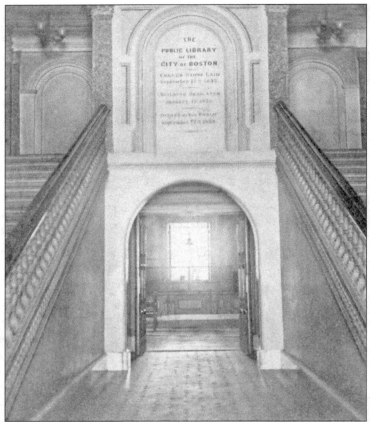

Upon entering the Boylston Street building, visitors were greeted by twin staircases that led up to the Bates Hall reading room. Over the archway leading into the circulating library room in the back of the first floor, the plaque reads, "The Public Library of the City of Boston. Corner stone laid September 17th, 1855. Building dedicated January 1st, 1858. Opened to the public September 17th, 1858."

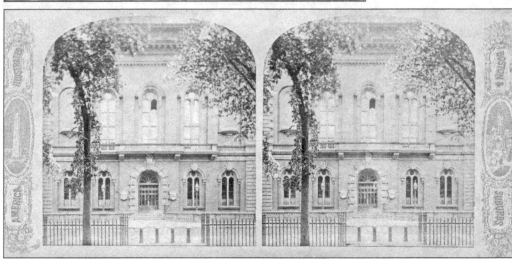

When the Boylston Street building opened to the 17,066 registered patrons on September 17, 1858, it contained 70,851 books and 17,938 pamphlets. The red brick, sandstone, and arched windows resulted in a combination of simplicity and grandeur. Although the building was known for its poor ventilation, only one window seems to be open in this image. The wrought iron fence that separated the Boston Common from Boylston Street is visible in the foreground.

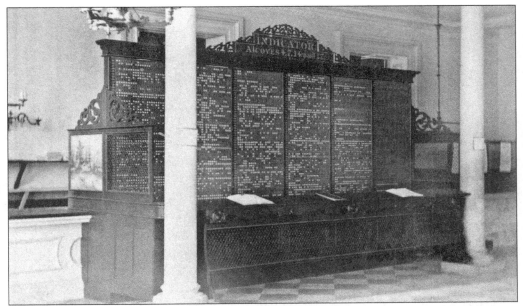

In 1867, head librarian Charles Coffin Jewett developed the Indicator Board, which was a large mechanical wooden frame that revealed at a glance whether a specific book was in or out. Shelf numbers were found at the end of each row of pins, and the number denoting the order of the book on the shelf is placed on each end of every pin. Staff reversed the position of the pin for every item they handled—black for in and white for out. This board applied only to books in alcoves 4, 7, 14, and 17, which were works of English fiction, including children's books.

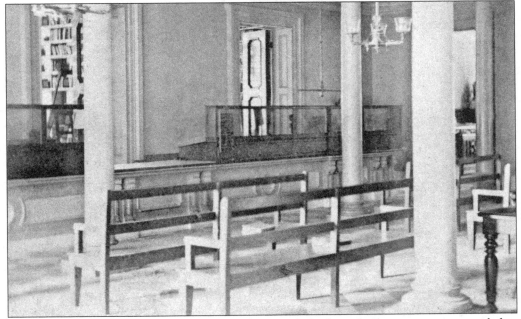

Since the popular fiction and nonfiction books were shelved in a back room, patrons needed to ask an attendant to retrieve their materials. While waiting for the library staff to return with the desired books, patrons could relax on the benches in the book delivery room.

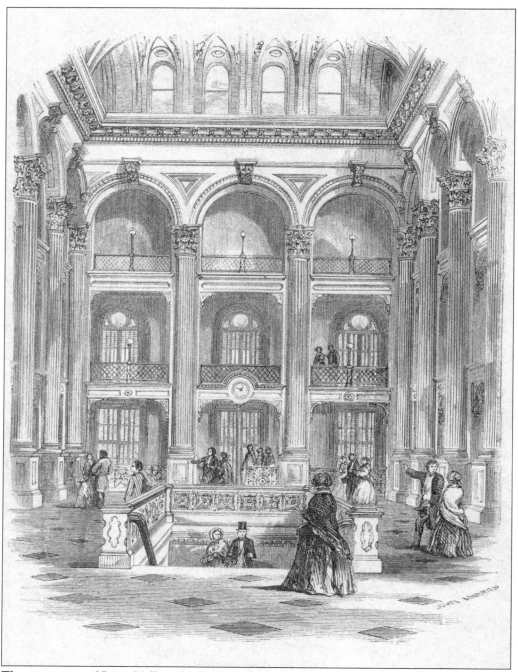

This engraving of Bates Hall in the Boylston Street building depicts men and women strolling around the room but shows no evidence of the 200,000 books and pamphlets shelved within the structure. Also conspicuously missing are any tables and chairs. This image was made before February 15, 1889, which is when the library contracted with Edison Electric Illuminating Company of Boston to provide electric lighting.

Two

Palace for the People

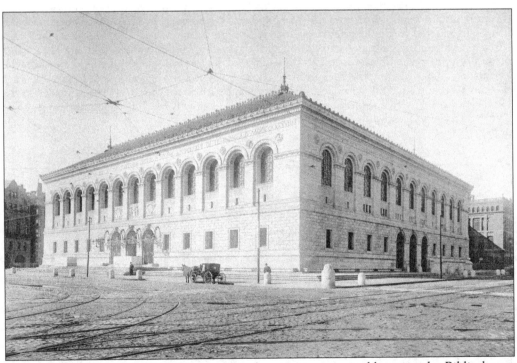

The building known as the McKim building bears a strong resemblance to the Bibliotheque Sainte-Genevieve in Paris. While the old Boylston Street building held 450,000 volumes, this impressive structure was designed to hold two million books. The new building, especially the Dartmouth Street facade, dramatically changed Copley Square.

By the early 1880s, the Boston Public Library had outgrown its building on Boylston Street, and the city announced a competition for the design of a new library. In 1884, twenty architectural firms participated in the competition, and the design above was placed among the top four winners. Although cash prizes were awarded, the city council determined that the library had no authority to make an award, and all the submitted designs were determined to be unsuitable. Ultimately, Mayor Hugh O'Brien authorized the trustees and the city architect to jointly award the contract, and in 1888, without any further competition, they awarded the contract to the New York firm of McKim, Mead, and White. Pictured below is McKim's original design of the Dartmouth Street facade.

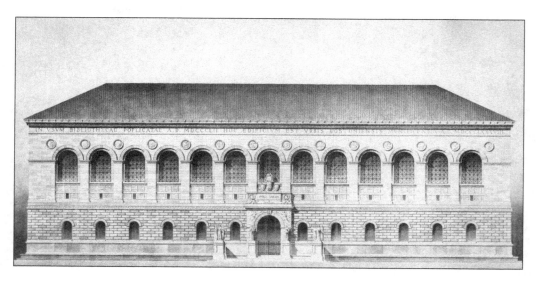

In 1872, Dr. Samuel N. Brown built his mansion on the corner of Dartmouth and St. James (now Blagden) Streets. In 1880, the state granted the city of Boston the abutting parcel on the corner of Dartmouth and Boylston Streets. Brown was not interested in selling his land to make way for the library, but the Massachusetts Legislature empowered the City of Boston, by Chapter 143, Acts 1882, to take the land if necessary. Brown's house was finally razed in 1888. On the right, the unfinished new Old South Church on Boylston Street is visible.

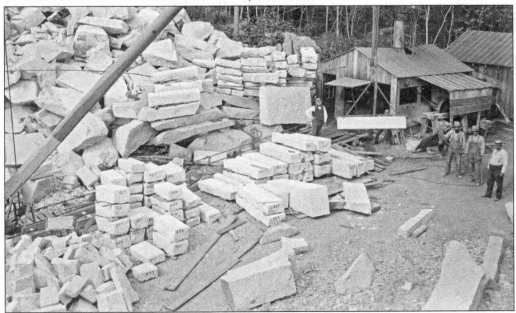

The granite used on the exterior of the building came from the Milford Pink Granite Company, located about 30 miles southwest of Boston. Each block was hewn to precise specifications and then numbered to ensure a tight fit with its adjacent blocks. The blocks in this photograph taken in 1888 are numbered and ready to be transported to the construction site.

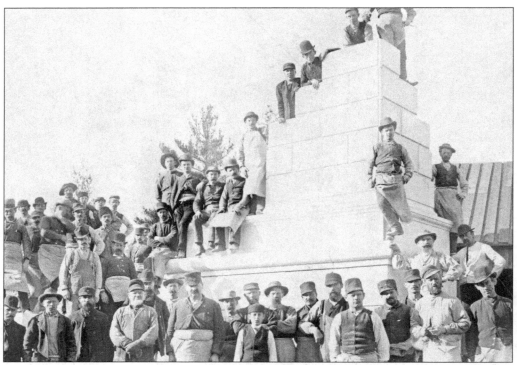

Quarry workers are posing on the cornerstone (above), which was temporarily assembled at the quarry prior to delivery to Copley Square. As the cornerstone was actually being installed for the McKim building in Copley Square on November 28, 1888 (below), the two copper boxes containing time capsules were momentarily visible. Among the articles inside the first box were a bronze medal commemorating the 250th anniversary of the Ancient and Honorable Artillery Company, all forms used in administering the library, heliotype plans of the new building, and a silver plate. The second box contained one copy of all the newspapers and magazines published in the Boston area, about 250 in total.

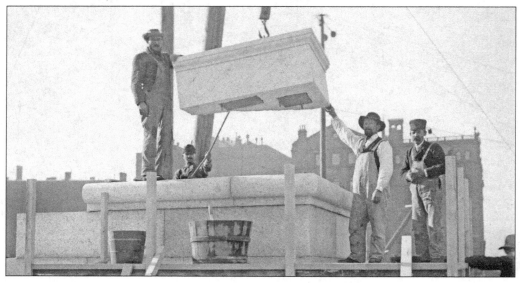

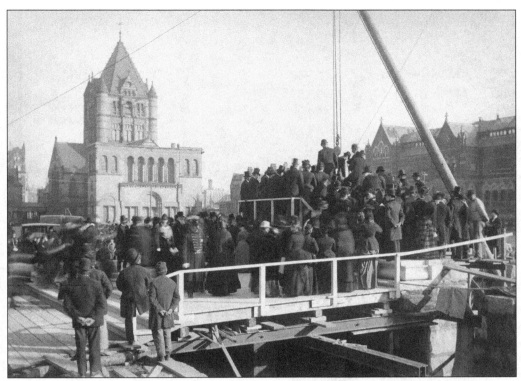

Dignitaries crowd the platform at the corner of Boylston and Dartmouth Streets as the cornerstone for the McKim building is lowered into place. Mayor Hugh O'Brien gave an address, and Oliver Wendell Holmes wrote and read a poem which included the line, "This palace is the people's own."

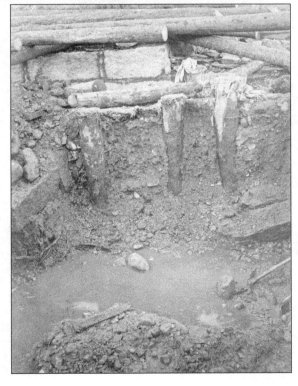

In the 1800s, the Back Bay of the Charles River was filled in to expand the size of Boston. The McKim building was constructed on this "made land." Because the landfill was very soft and the natural water level was so high, the foundation had to be reinforced with 4,500 wooden pilings that were driven into the bedrock as much as 70 feet below ground level. This photograph shows the top section of three of these pilings.

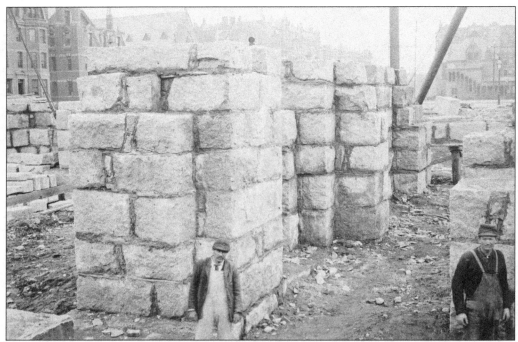

Workmen are posing next to the granite support piers in the foundation near the corner of Boylston and Dartmouth Streets.

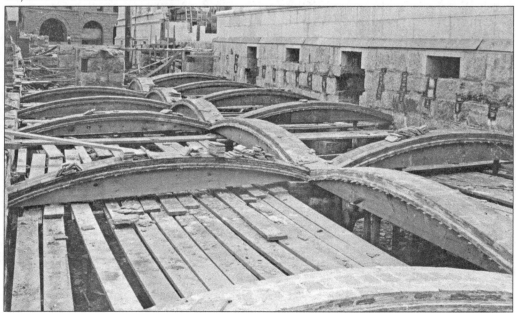

Rafael Guastavino was an immigrant from Spain who brought with him a technique of constructing tile vaults and arches that were incredibly strong, relatively light, self-supporting, and resistant to damage and breach by fire. Guastavino vaults were used extensively throughout the library. This photograph shows the framework used to build the vaults beneath the platform and steps outside the McKim entrance.

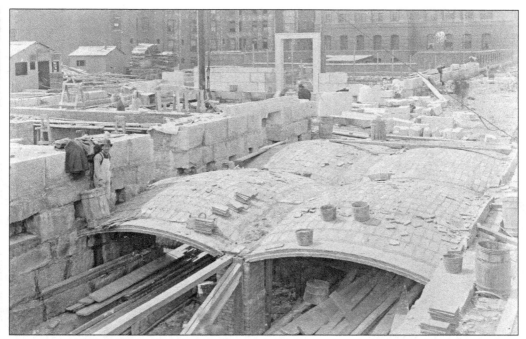

Five layers of interlocking terra-cotta tiles and a special thin mortar were used to construct the Guastavino vaults used throughout the building.

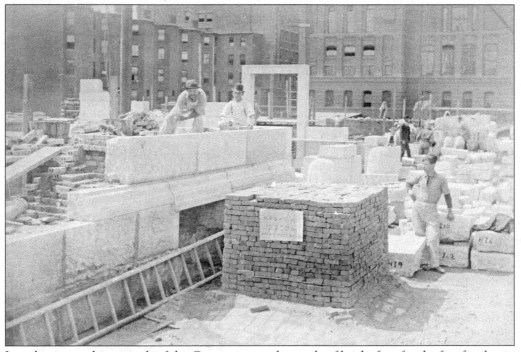

In order to test the strength of the Guastavino vaults, a pile of bricks four feet by five feet by six feet was constructed. This amounted to 12,200 pounds placed on top of one vault. The vault and tiles passed the test.

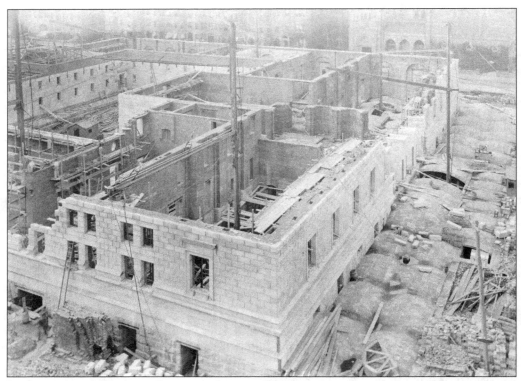

Looking towards Boylston Street, on can see that the construction of both the interior and exterior walls has reached the second floor. To the right, the completed Guastavino tile vaults under the Dartmouth Street platform are visible. A small glimpse of the new Old South Church can be seen in the upper right corner.

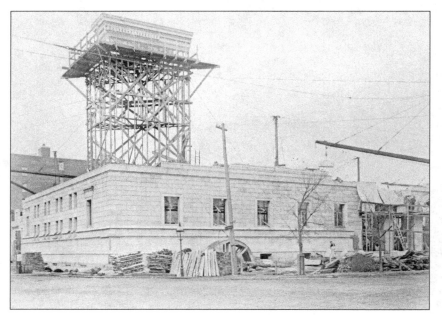

In order to verify that the proportions of the building were aesthetically pleasing, a mock-up of the proposed cornice was constructed on scaffolding at the southeast corner of the structure.

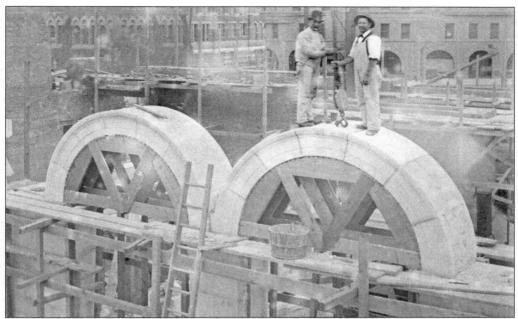

The granite arches over the second-floor windows were assembled on wooden support frames. Here, two men stand atop an arch on the Boylston Street side of the building immediately after the keystone was installed.

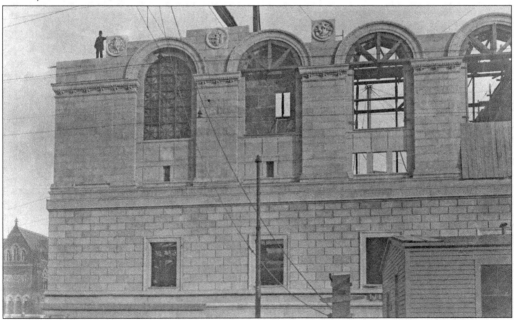

The progress of the second floor window construction and the medallion placement can be seen in this photograph. To get a sense of the size of the windows, see the man standing at the corner of the exterior wall next to a medallion. The 33 medallions that surround the building were created by Domingo Mora and represent the colophons or trade devices of early printers and booksellers.

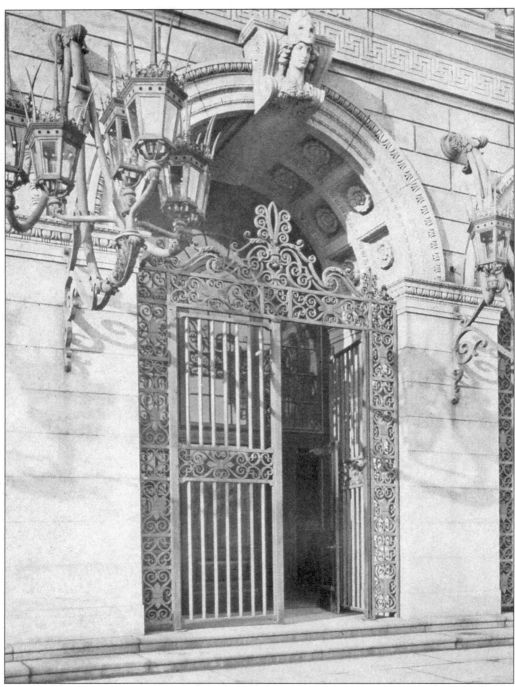

Pictured is one of the hand-forged and hand-hammered wrought iron lamps and one of the decorative ironwork gates by the Dartmouth Street entrance of the McKim building. These 12-foot-high lamps have become an iconic symbol of the library. The image on the keystone over the center arch represents Minerva, the goddess of wisdom.

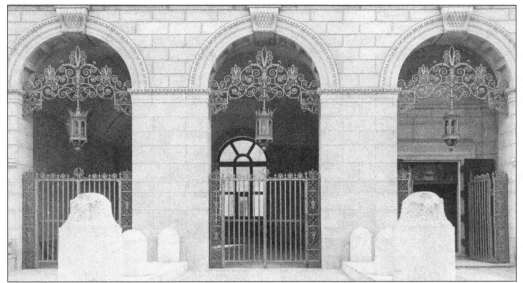

The entrance on Boylston Street was especially beautiful, and through it one could catch a glimpse of the courtyard. It was originally a porte cochere that allowed the trustees and other dignitaries to step out of their horse-drawn carriages protected from the weather. This extravagance was short lived, and by 1898, the area was transformed into the periodicals room. The lamps and decorative ironwork over the gates complement the ones on the Dartmouth Street entrance. In 1921, the Massachusetts Bay Transportation Authority's Copley subway station entrance was built directly in front of these gates.

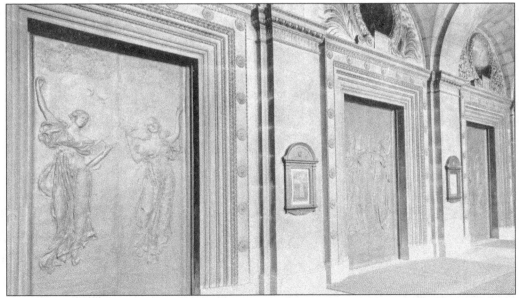

The three sets of bronze double doors in the vestibule were designed by Daniel Chester French. Each individual door weighs approximately 1,400 pounds, and they took 11 years to finish. Each door contains an allegorical figure in low relief. On the left-hand doors are figures of *Music* and *Poetry*, on the center doors are *Knowledge* and *Wisdom*, and on the right-hand doors are *Truth* and *Romance*.

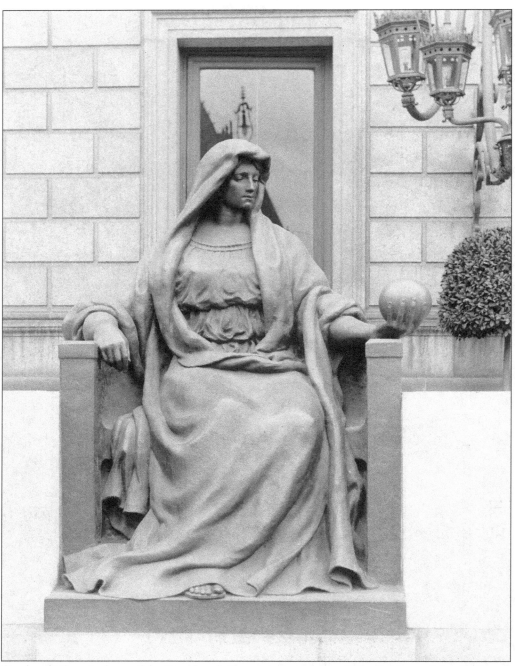

On the platform in front of the Dartmouth Street entrance, one will find two seated female figures in bronze. Originally, this project was given to Augustus Saint-Gaudens, but after his untimely death in 1907, Bela L. Pratt, a Boston artist, completed the twin sculptures in 1911. The figure to the left of the main entrance personifies Science. The names carved in the pedestal are Newton, Darwin, Franklin, Morse, Pasteur, Cuvier, Helmholtz, and Humboldt.

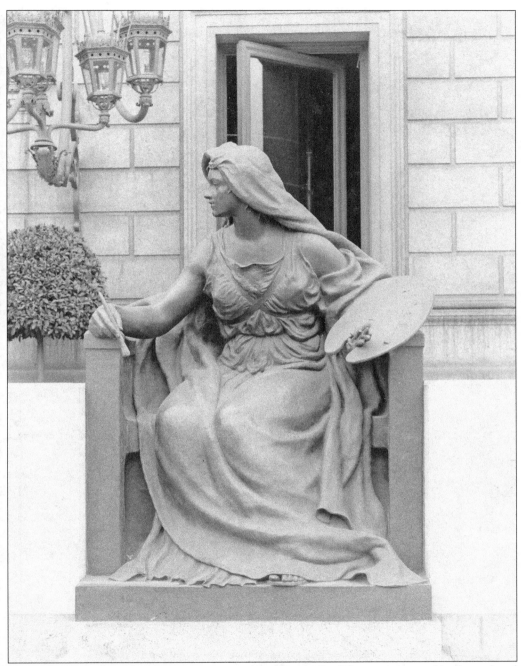

The sculpture to the right of the main entrance represents Art. The names carved in the pedestal are Raphael, Titian, Rembrandt, Velasquez, Phidias, Praxiteles, Michelangelo, and Donatello. In 1899, Augustus Saint-Gaudens's original concept for these statues was much different. On one side, a male figure depicting Labor was seated between two female figures personifying Science and Art. On the other pedestal was a male figure representing Law between female figures of Power and Religion.

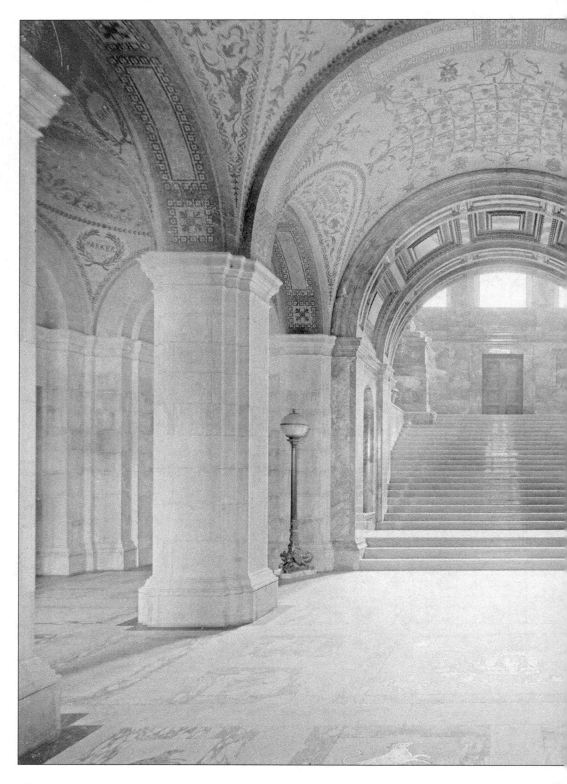

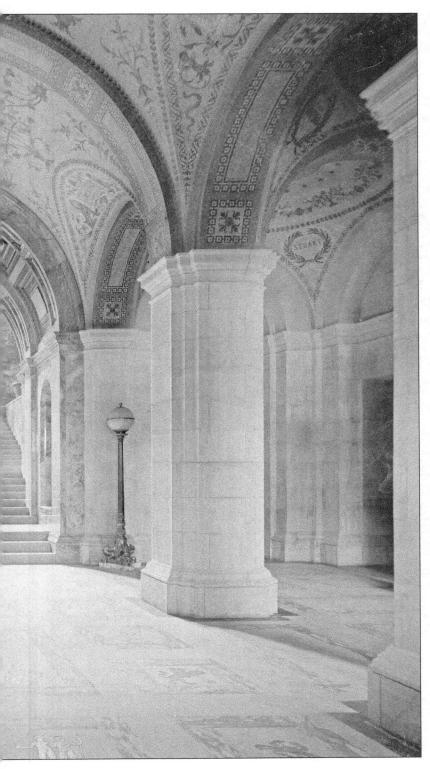

After passing through the vestibule, visitors are presented with this dramatic view of the entrance hall looking toward the grand staircase. The walls are yellow siena marble, and the steps are French echaillon marble, which is full of fossil shells. Other architectural details include the coffered marble arch at the foot of the staircase, the sweeping mosaic ceilings, and the brass zodiac inlays in the white Georgia marble floor. The zodiac was designed by George Gaynar and fabricated by John Williams, Tiffany's metal worker. The inlays had previously been installed in the New York State Building at the 1893 Columbian Exposition in Chicago. The 30 surnames in the mosaic ceiling include famous and distinguished Bostonians from six different professions— theologians, reformers, scientists, artists, historians, and jurists.

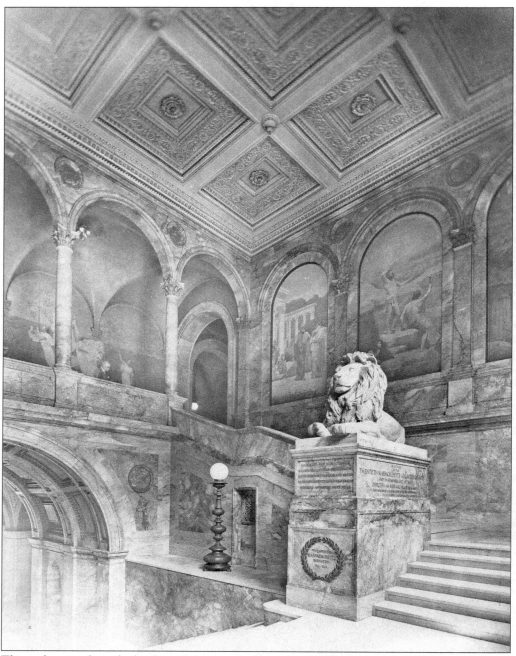

This is the view from the landing of the grand staircase in the McKim building, looking up toward the Puvis de Chavannes murals. The tone of the whole series of murals is of classic serenity, and it harmonizes with the Corinthian columns. In the foreground sits one of the twin regal lions couchant carved by Louis Saint-Gaudens from solid blocks of unpolished Siena marble. The statues are memorials to the 2nd and 20th Regiments of the Massachusetts Volunteer Infantry.

Bates Hall, the great neoclassical reading room, was named for the first great benefactor of the library, Joshua Bates. It is architecturally the most important room in the building. It has a rich barrel vaulted ceiling with half domes at each end. It is 218 feet long, 42.5 feet wide, and 50 feet high. The terrazzo floor is bordered by yellow Verona marble, and the hall is surrounded by English oak bookcases.

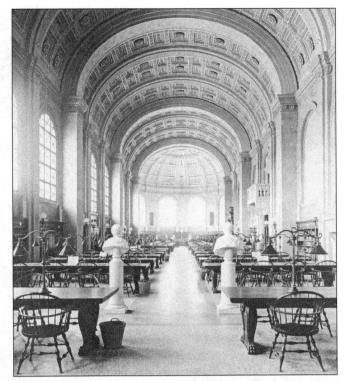

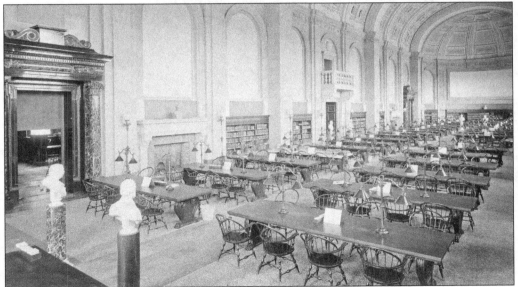

This view of Bates Hall includes the ornate doorway of black Belgian and Alps green serpentine marble, with columns crowned by bronze Corinthian capitals, leading into the Abbey Room. The busts and statues throughout the room represent great authors and eminent Bostonians. James McNeill Whistler proposed a series of murals for this room, but they were never executed, partly because he delayed and partly because of a lack of money. The library undoubtedly lost a valuable work of art. The walls in this room remain blank to this day.

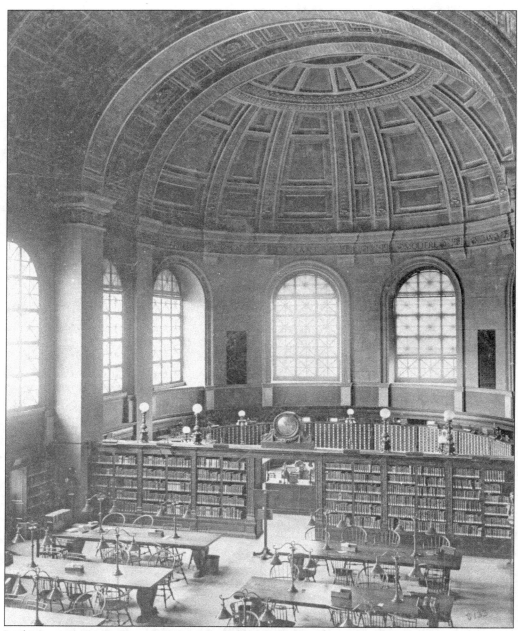

In the semicircular enclosure behind the oak bookshelves at the south end of Bates Hall, one would find the card catalog. When this picture was taken in 1910, there were 2,743 drawers containing cards listing the authors, titles, subjects, and series of all the books in the research library.

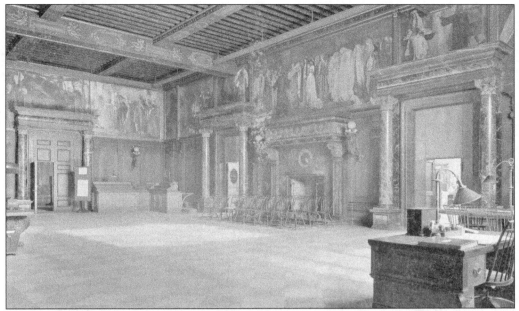

In 1909, people would wait in the delivery room for their books to take home. The room is in the style of the early Venetian Renaissance. The walls in this room have a high oak wainscot and the ceiling has heavy, lead-gilded beams. Around the entire room, Edwin Austin Abbey's mural sequence titled *Quest of the Holy Grail* creates an amazing frieze.

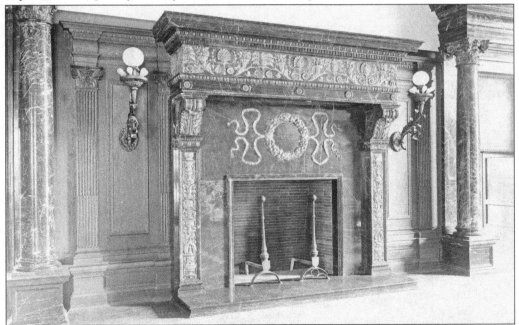

The marble fireplace mantle in the delivery room (now known as the Abbey Room) is ornately carved with Renaissance ornamentation and has blood red rouge antique marble pilasters. On both sides of the fireplace, one can see the Corinthian columns made from Levanto marble that frame the doorways that lead into Bates Hall.

This close-up of one of the panels of the Abbey murals in the delivery room depicts Blanchefleur, Sir Galahad's bride. The 15 panels illustrate the Arthurian legend of the adventures of Sir Galahad and the other knights of the Round Table and their quest for the Holy Grail. The eight-foot-high murals were painted in Abbey's studio in Fairford, England, between 1890 and 1901.

Through these three windows in the Delivery Room (now the Abbey Room) one can see the first configuration of the Tube Room. Call slips were sent from this room through one of the 53 pneumatic tubes to stations on each of the six floors in the closed stacks. The books were retrieved from the shelves and placed in small cars on one of the railways, which all ended at the automatic elevators (seen along the back wall). The elevators transported the books back to the Tube Room, and library staff then delivered the items to the patrons waiting in the Delivery Room.

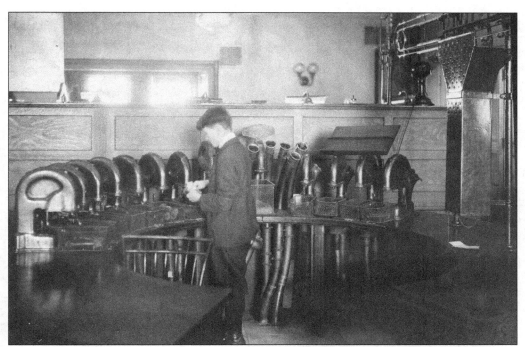

In 1898, the layout of the Tube Room was changed, and the number of tubes was reduced. The upright tubes to the immediate right of the young boy were used to speak to staff on each of the stacks.

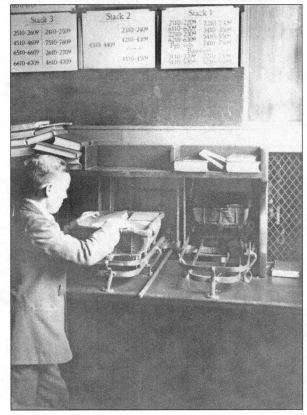

Stack 3		Stack 2		Stack 1	
2510-2609	2410-2509		2310-2409	2510-2209	7200-73AM
4510-4609	7510-7609	4310-4409	4210-4309	6110-6309	3410-35CN
6510-6609	2610-2709		2210-2309		5410-55CN
6610-6709	4610-4709		4410-4509	6210-6309	7410-75CN
				Pph vols	
				Basement	
				3110-3310	3210-33AM
				5110-53AM	5210-54CN

This is a close-up of two of the six book elevators that were along the back wall of the Tube Room. Above each elevator was a list of the call number ranges of the books shelved on each of the stacks.

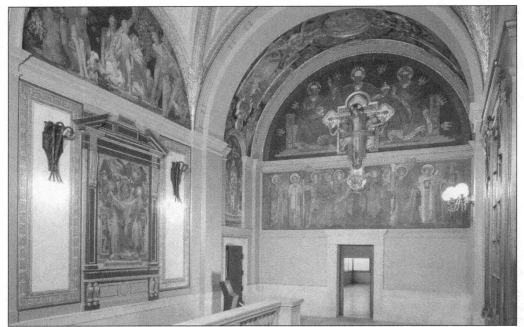

John Singer Sargent's magnificent and powerful mural sequence *The Triumph of Religion* is the dominating feature of the third-floor hall in the McKim building. The subject was chosen by Sargent and represents the development of religious thought from Paganism through Judaism to Christianity. The hall is 84 feet long, 23 feet wide, and 26 feet high. The Christian portion of the murals at the south end of the hall represents the Trinity and the dogma of the redemption.

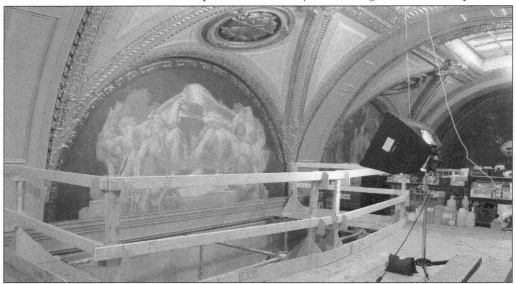

In the 1990s, a major restoration was undertaken to restore sections of the McKim building, including the John Singer Sargent murals. One of the artists restoring the murals found an old cigar stub lying on an upper ledge. Sargent, who was known to have smoked while working, may well have left this curious token. Here, scaffolding surrounds the image entitled *The Law*, which is one of the three Judaic lunettes on the east wall above the staircase.

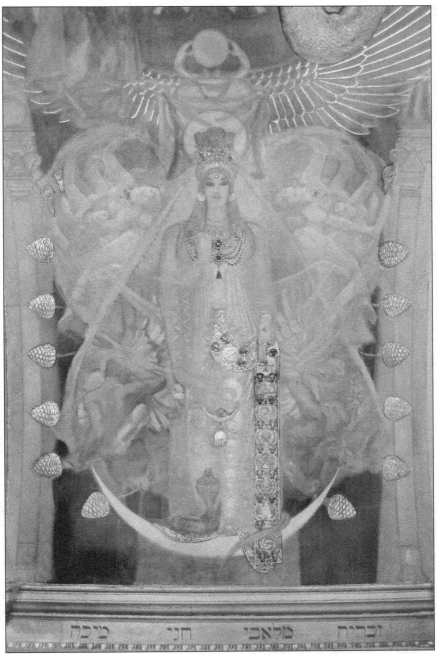

On the vaulting are the pagan deities, including this panel of the Phoenician goddess of the moon, Astarte. Her delicate, ethereal, and sensual beauty stands in stark contrast to her association with the powers of evil and war. These murals are not simply flat paintings on a wall, but are in fact embellished with three-dimensional objects. Astarte's gown is trimmed with a beautiful gold edge, and Sargent adorned her headdress, necklace, and forehead with "jewels" made from blue, yellow, and green cut glass. These faceted glass pieces are mounted in metal bezels and nailed to the mural.

This and the following two images show the progression of the construction of the west corridor of the Special Libraries floor, which encompassed the entire third floor of the McKim building. Only the steel framing for the ceiling and the alcove columns had been installed at the time of this photograph.

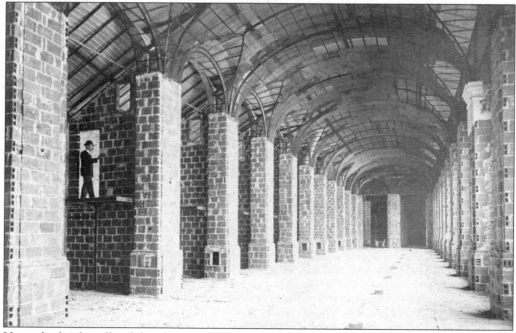

Here, the brick walls of the alcoves and columns are completed and the balcony floors are in place. One plastered pilaster capital on the courtyard side is completed (right). Note the man in the derby standing in the balcony doorway at left.

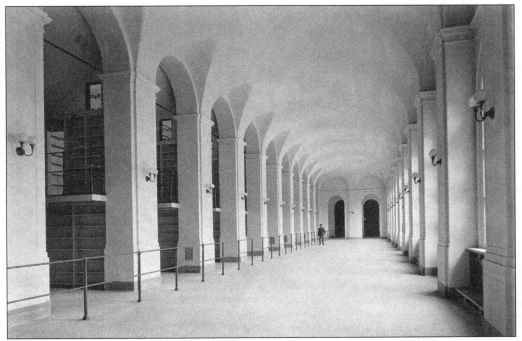

In this third view of the west corridor of the Special Libraries floor, one can see the completed nine alcoves, the two arched doorways at the end of the room, and the barrel vaulted ceiling. To get a sense of the size of this area, note the man standing near the rear of the room.

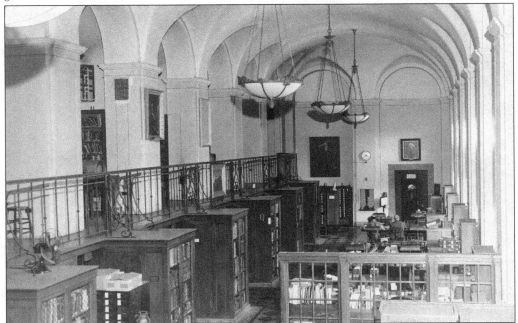

This c. 1950 photograph includes a portion of the Rare Book Department on the north side of the Special Libraries floor. This department housed rare and valuable books, manuscripts, and incunabula.

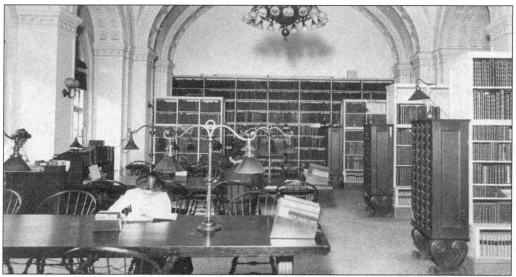

In 1894, Allen A. Brown donated his valuable collection of over 15,000 music books and scores to the Boston Public Library. In this photograph, one can see a woman studying one of the handsomely bound volumes in the Allen A. Brown Music Room, which was on the third floor of the McKim building. This room is one of the most attractive rooms in the building, and it draws natural light from large windows that look out on the courtyard. Its low ceiling is arranged in beautiful arches. This room was later used as the Treasure Room, which served as the center for exhibitions of rare books, manuscripts, and other similar materials of great value. It is now known as the Cheverus Room, where the Joan of Arc collection is kept.

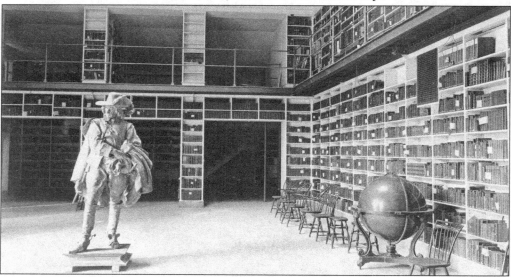

This is the statue of Sir Harry Vane, governor of the Massachusetts Bay Colony in 1636. The bronze statue was created by Frederick W. MacMonnies. He also created the *Bacchante and the Infant Faun*, which stands in the fountain in the courtyard today. Before finding its current home in the Dartmouth Street vestibule, the statue of Vane was displayed here in the Barton Room on the Special Libraries floor. At the time of this photograph, the room housed the rarest treasures of the library.

Albert H. Wiggin of New York donated his vast collection of 19th- and 20th-century prints and drawings to the Boston Public Library in 1941. Because of this generous donation, the Print Department was established. The Wiggin Gallery on the third floor on the McKim building was used for art exhibitions. This large study room was situated adjacent to the gallery's balcony on the fourth floor.

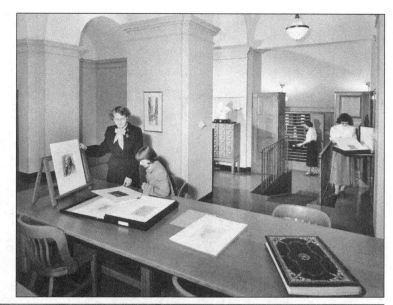

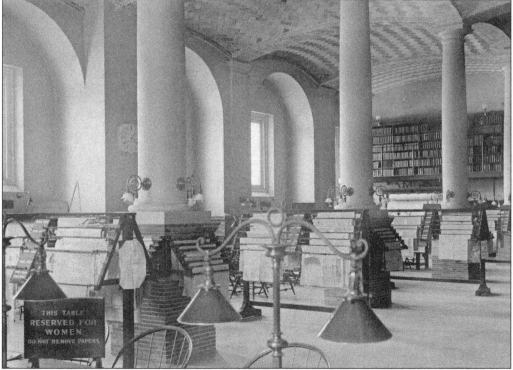

When this picture was taken in 1900, the Boston Public Library subscribed to 378 newspapers. Of these, 211 were American, 58 were British, and the remainder represented newspapers from 16 other countries. In order to prevent scattering and separation, the newspapers were secured on long poles that were displayed on wooden racks. Before the internet, television, and even before radio, newspapers were virtually the only source of news and other information. Overhead, one can see Rafael Guastavino's beautiful vaulted ceiling.

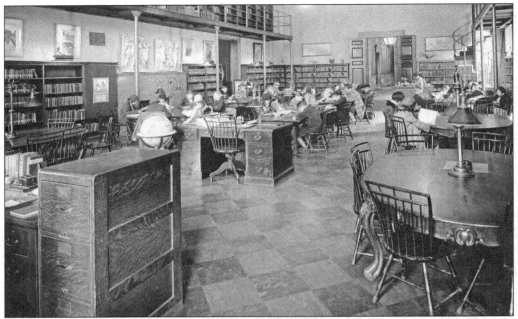

The Boston Public Library was the first in the country to establish a separate Children's Room. Although Justin Winsor originally envisioned in the 1870s a room that was designed especially for children, it was not until 1895 that the Children's Room was opened in the McKim building. Thousands of books and pamphlets were finally within reach of Boston's youth.

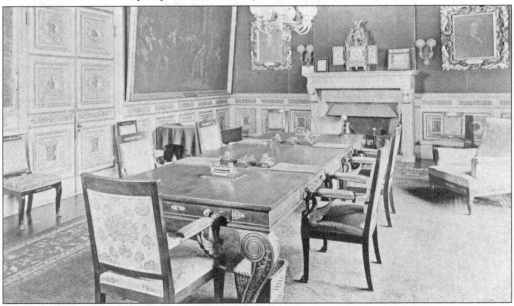

The French Renaissance mantelpiece pictured above was moved from the Trustees Room in the Kirby building on Boylston Street to the new Trustees Room in the McKim building. It was made of white limestone and has beautifully carved arabesques. The intricate woodwork in this room came from a chateau in France. Curiously, this picture from 1926 includes two very similar portraits of Benjamin Franklin displayed on each side of the fireplace.

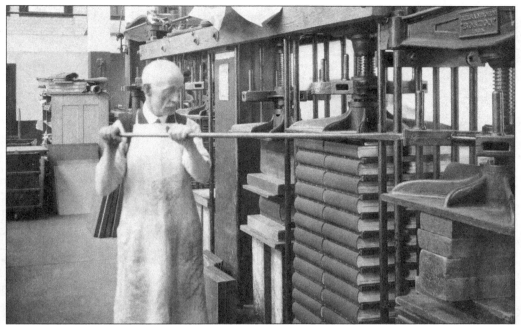

The library moved their bindery from Stanhope Street to Columbus Avenue in 1912 and employed 29 people in 1914. The department handled such tasks as mounting photographs and engravings, repairing books, stitching periodicals, preparing library publications for use, and binding approximately 30,000 volumes annually. The bookbinder seen here is standing in front of a row of book presses, one of which he is operating.

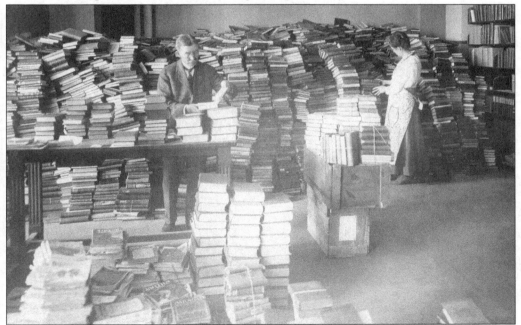

Each day, many hundreds of books and periodicals were sorted and delivered to and from the central library, the bindery, branches, reading rooms, and delivery stations all over the city.

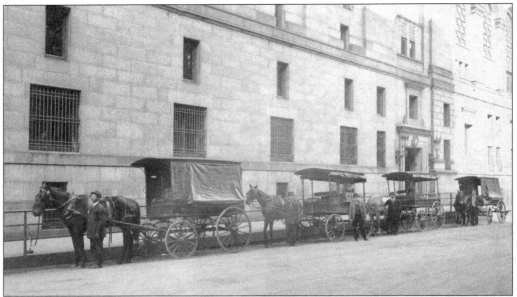

Four horse-drawn delivery wagons and their drivers are lined up on Blagden Street behind the library awaiting their next journey. These vehicles were used to transport books and supplies to the other library buildings in Boston.

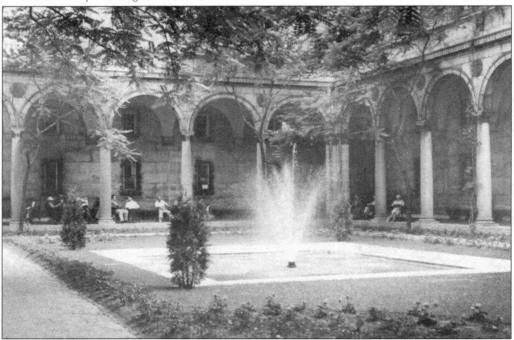

The interior courtyard is a major architectural feature of the McKim building, one that many are surprised to discover. The vaulted arcade is almost an exact copy of the Palazzo della Cancelleria built in Rome in the 15th century. Over the years, different landscaping was used to soften the granite, marble, and bricks that surround this peaceful and tranquil space. In 1976, when this photograph was taken, four large Japanese maple trees provided additional shade to visitors.

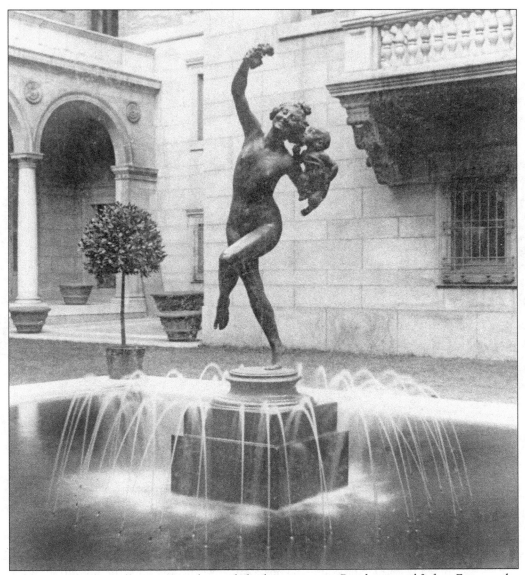

Architect Charles Follen McKim donated the bronze statue *Bacchante and Infant Faun* to the library. The statue, created by Frederick MacMonnies, immediately caused controversy throughout Boston. One newspaper headline read, "Too Naughty for Boston Library," while another newspaper proclaimed, "Bacchante Coming. Art Commission will set up Naked Drunken Woman for Inspection." The Congregational Club sent a petition to remove the statue. The petition claimed, in part, that the statue represents "reckless abandon to sensual pleasure, thoughtlessness, intoxication, and the supreme reign of the grosser nature, excited and inspired by draughts of wine." The Art Commission of the City of Boston ultimately rejected the statue, and in June 1896, McKim withdrew his gift. The original statue was sent to the Metropolitan Museum of Art in New York. There are two important footnotes to this story. First, soon after the statue was removed from the library, a bronze replica was donated to Boston's Museum of Fine Arts, where it was put on display without protest. Second, in the 1990s, another bronze replica of this "scandalous" statue was created, and the *Bacchante* was finally returned to her home in the courtyard.

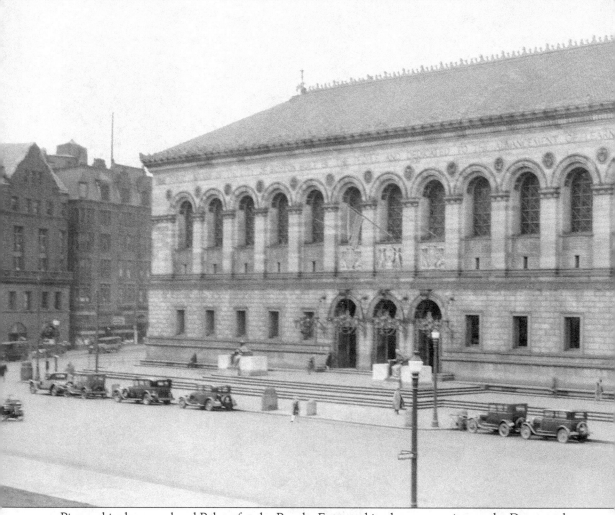

Pictured is the completed Palace for the People. Engraved in the top cornice on the Dartmouth Street facade, one can read the following inscription: "The Public Library of the City of Boston Built by the People and Dedicated to the Advancement of Learning. A.D. MDCCCLXXXVIII." The Boylston Street cornice proclaims, "The Commonwealth Requires the Education of the

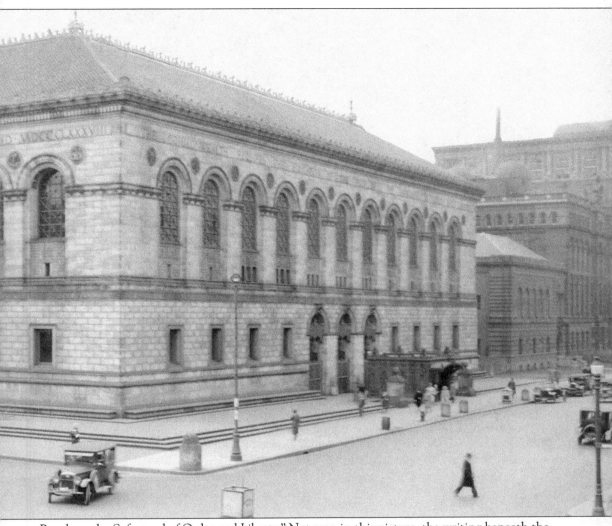

People as the Safeguard of Order and Liberty." Not seen in this picture, the writing beneath the Blagden Street roof reads. "MDCCCLII. Founded Through the Munificence and Public Spirit of Citizens."

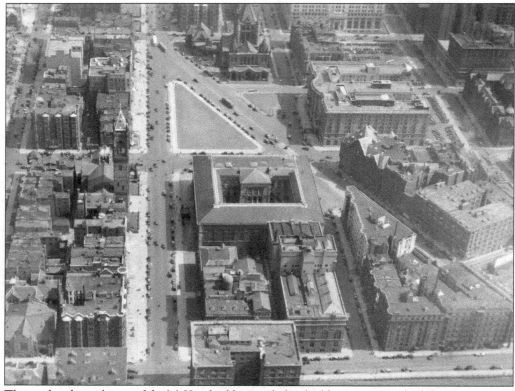

This undated aerial view of the McKim building includes the library annex, which was constructed adjacent to the back of the building along Blagden Street in 1918. This is also a good photograph of the entire Copley Square area, including Trinity Church, the Copley Plaza Hotel, the S.S. Pierce building, and the new Old South Church. Because Huntington Avenue still runs diagonally through the square, this image can be dated to before 1966.

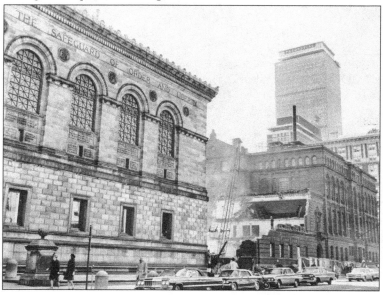

The size of the central library in Copley Square doubled in 1972, when the new Philip Johnson building was opened. Before the new library could be built, several structures needed to be torn down, including Boston University's Jacob Sleeper Hall and the old Harvard Medical School building.

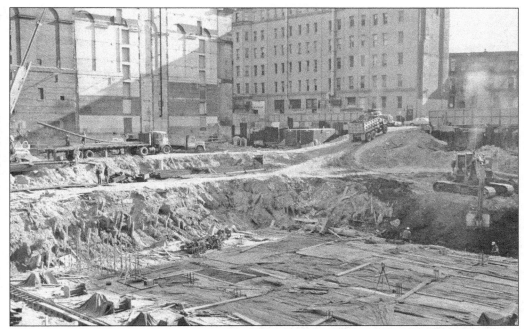

The Johnson building was constructed immediately adjacent to the McKim building so that staff and the public would be able to move freely between them without stepping outside. Here, one can see the excavation for the Johnson building. The McKim building is visible to the left rear of the construction area. The white walls on the McKim exterior show where the annex was located before it was torn down to make way for the Johnson building.

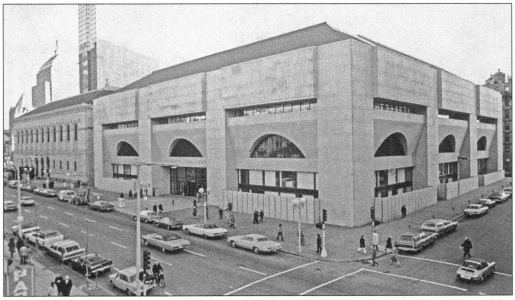

The two requirements for the Johnson building were that it observe the existing roof line of the McKim building and that Milford pink granite, which would harmonize with the exterior of the McKim building, be used. Although noted for his extensive use of glass in his buildings, Philip Johnson broke with this principle when he designed this building.

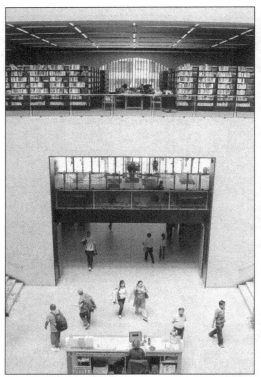

The modern Johnson building stands in stark contrast to the classical McKim building. This photograph was taken from the second floor, looking down past the mezzanine level into the Deferrari Hall on the first floor. When John Deferrari informed the trustees of the $1 million he intended to give the library, he said that he "became a millionaire without benefit of a banker, a secretary, a bookkeeper, an automobile, or a telephone." He then said that his "wealth had come from intelligent use of the library, and I am glad to return it to the source." (Photograph by Catherine Willis.)

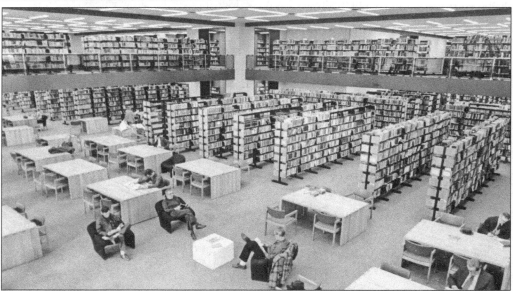

Once completed, the Johnson building contained 450,000 books readily available on open shelves, an enlarged Children's Room, an expanded young adult collection, 50,000 foreign language materials, a modern audio visual department, and a 374-seat lecture hall named after the generous benefactor Sidney Rabb. The interior of the Johnson building was designed to serve as a robust resource center for the city of Boston, but people also found it to be a comfortable place to sit and read popular books and magazines.

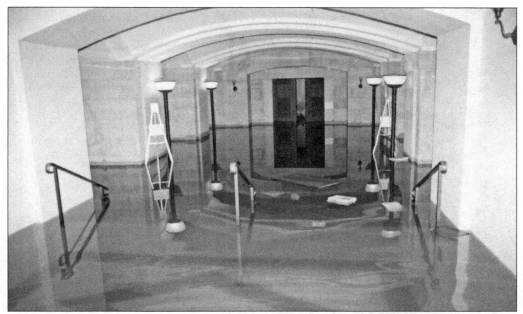

One of the city's oldest and largest water mains ruptured and dumped about three feet of water in the newly renovated library basement on August 16, 1998. Almost every book on the first two shelves of the basement book stacks was soaked and expanded to more than 1.5 times its original size. Some became so heavy they broke the shelves and spilled onto the floor.

The Peabody and Stearns collection of architectural drawings is stored in the attic of the Johnson building. The collection includes more than 1,400 blueprints, architectural plans, and drawings of Boston-area buildings that were constructed between 1870 and 1917. (Photograph by Catherine Willis.)

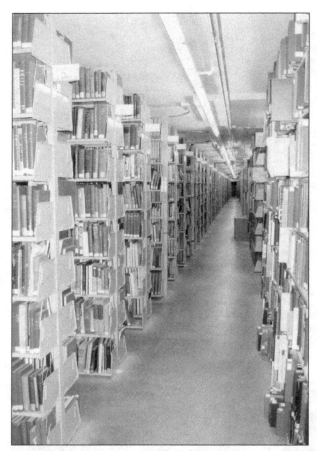

There are four floors of closed stacks in the Johnson building, and they hold hundreds of thousands of books, journals, pamphlets, and prints used for scholarly research. (Photograph by Catherine Willis.

Once an item from the closed shelves in the Johnson building is retrieved by library staff, the item travels down this conveyor belt, through an opening between the Johnson and McKim buildings, and down to the second floor in the McKim building, where it is delivered to the patron. (Photograph by Catherine Willis.)

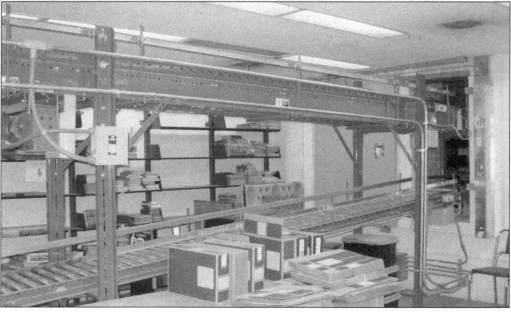

Three

LEADERS AND READERS

The original idea for a library in the city of Boston was first proposed in 1841 by the French ventriloquist and impersonator Nicholas Marie Alexandre Vattemare. Although he was a great promoter of a system of cultural exchanges between libraries and museums, it was not until 1847 that the first books, maps, and engravings were exchanged between Paris and Boston. His gift of 96 volumes was deposited on the third floor of city hall, and they are considered to be the library's first items.

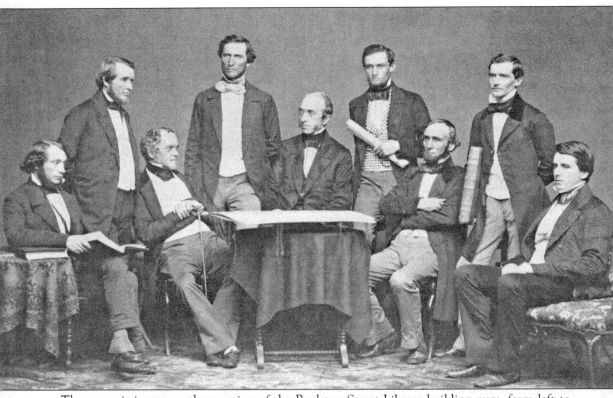

The commissioners on the erection of the Boylston Street Library building were, from left to right, Samuel J. Ward, Nathaniel B. Shurtleff (trustee), George Ticknor (trustee), Edward F. Porter, Robert C. Winthrop (president of the board of trustees), Charles K. Kirby (architect), Charles Woodberry, Edward Capen (librarian), and Joseph A. Pond.

London banker Joshua Bates was the library's first great benefactor. In 1852, Boston-born Bates read the first report of the library trustees and was moved to donate $50,000. One of the conditions of the gift was that the building was to be an "ornament to the city." He later donated another $50,000 worth of books. Bates Hall was named in honor of his great contribution.

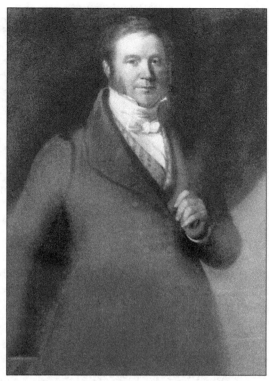

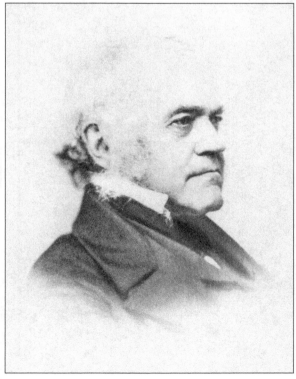

George Ticknor was a library trustee from 1852 to 1866 and president in 1865. He was an early supporter of the library and deeply believed in the concept of freely circulating popular materials to the public. In 1856, he traveled abroad at his own expense to purchase 26,618 books for the new Boylston Street building, using the generous gift of $50,000 received from Joshua Bates. Ticknor was a remarkable scholar and a Harvard professor of Spanish and French. In 1871, he bequeathed his personal collection of rare Spanish and Portuguese language materials to the library.

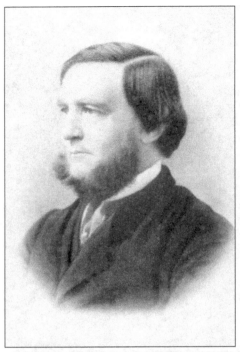

Charles Coffin Jewett was superintendent from 1858 to 1868. He was the librarian and assistant secretary of the Smithsonian Institution before becoming superintendent of the Boston Public Library. Jewett was a strong advocate of descriptive, alphabetical catalogs of the items in a library because of their user-friendly nature.

This photograph of the trustees was taken in the Boylston Street building in 1893. Seated in this image are, from left to right, Henry W. Haynes, Frederick O. Prince, Samuel A.B. Abbot (president), William R. Richards, and Phineas Pierce. The extraordinary clock, made of hand-chiseled gilt bronze, was created by Mathieu Planchon. It was exhibited at the Paris Exposition in 1889 as a work of art and won the gold medal. Both the clock and the intricately carved gray limestone mantle were moved into the Trustees Room in the new McKim building.

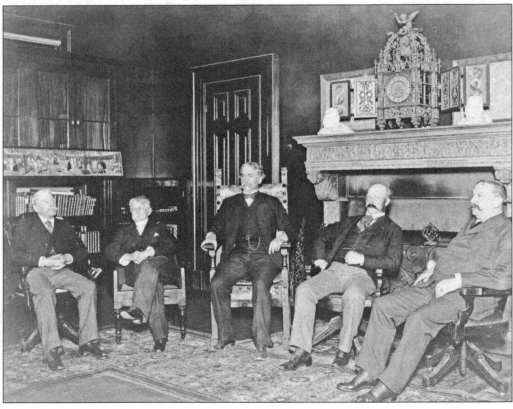

Justin Winsor was superintendent from 1868 to 1877. In an effort to increase book use, he worked for the establishment of branch libraries, extended hours, and relaxed restrictions on use. Winsor was one of the creators of the librarian profession. He was a founder of the American Library Association (ALA), serving as its president from 1876 to 1885, and was also a founder of the *Library Journal*.

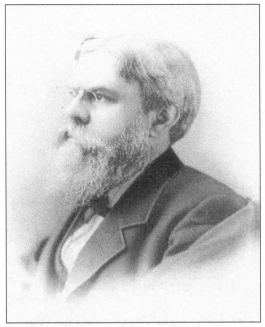

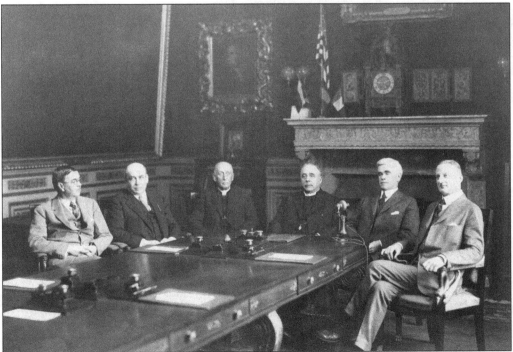

This image of the trustees was taken in the McKim building in 1920. Seated in this photograph are, from left to right, Guy W. Currier, Louis E. Kirstein, Msgr. Arthur T. Connolly, Dr. Alexander Mann (president), Michael J. Murray, and Charles Francis Dorr Belden (director). Belden was also the president of the ALA, from 1925 from 1926. The French Renaissance mantelpiece and beautiful clock were previously in the Trustees Room in the Boylston Street building.

Frederick Octavius Prince was elected mayor of Boston in 1876 and became a trustee of the library in 1888, the same year the firm of McKim, Mead, and White was selected to design the new building. In 1895, Prince was elected president of trustees, a position he held until 1899. During the controversy over the placement of the statue of *Bacchante and Infant Faun* in the courtyard, he cast the only vote to accept the gift.

The architects of the McKim building are, from left to right, William Rutherford Mead, Charles Follen McKim, and Stanford White. McKim was the primary designer, and his appreciation for the use of painting and sculpture in the decoration of a building is apparent.

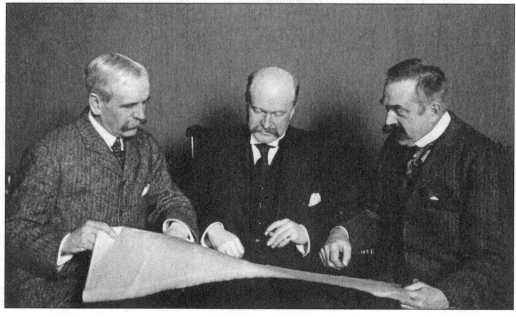

Herbert Putnam was librarian from 1895 to 1899. The library has been fortunate in having for its librarians a succession of accomplished men and for the first time in 2008, a woman. After Putnam left the Boston Public Library, he served 40 years as the librarian of Congress. Putnam introduced a new system of classifying books that continues to this day, as the Library of Congress Classification. He was president of the American Library Association from 1903 to 1904.

Horace Greeley Wadlin was selected librarian in 1903, even though he had never before worked in a library. He studied architecture and, just before his appointment to the library, was the chief of the Massachusetts Bureau of Statistics of Labor. His administration focused on the business aspects of the library, and throughout the following 14 years, the library saw virtually no new innovation.

The artist John Singer Sargent is the creator of the library's most famous mural, *The Triumph of Religion*. Sargent installed his masterpiece in four sections between 1895 and 1919. The death of Sargent in 1925 left the center panel above the stairway unfinished.

American-born painter Edwin Austin Abbey was living in England when he was commissioned to paint the magnificent mural sequence titled *Quest of the Holy Grail*. Abbey was one of the most celebrated illustrative artists of his day. He was elected to the Royal Academy and admitted to the elite artistic circle of the Pre-Raphaelites.

Louis Edward Kirstein was a trustee of the library from 1919 through 1942 and was elected president of trustees on five separate occasions. In 1928, Kirstein donated a building to the library as a memorial to his father, Edward Kirstein. The location was convenient to the business district in downtown Boston and was to be used as a business reference branch.

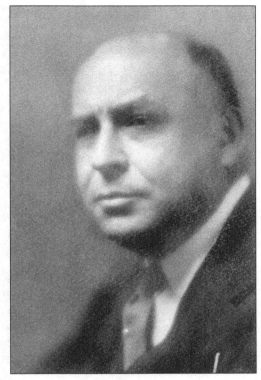

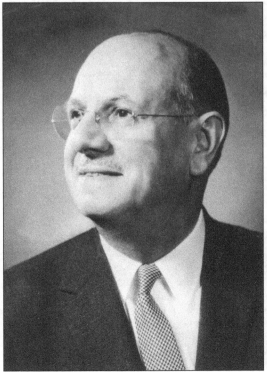

The Rabb Lecture Hall, in the Johnson building, was named after one of the library's great benefactors, Sidney Rabb. Born in 1900, Rabb started working in his uncle's grocery store at a young age. By the time of his death in 1985, he had grown a company of 113 Stop & Shop supermarkets. The library's auditorium seats up to 342 people.

69

Milton Lord, director and librarian from 1932 to 1965, became interested in libraries while studying at Harvard and working part time as an assistant in the library. One of the interesting jobs he held before coming to the Boston Public Library in 1932 was as a librarian at the American Academy in Rome, where he assisted in the recataloging of the Vatican library. Lord led the Boston Public Library longer than any other person, and after 33 years of service, he retired in 1965. He was also the president of the ALA from 1949 to 1950.

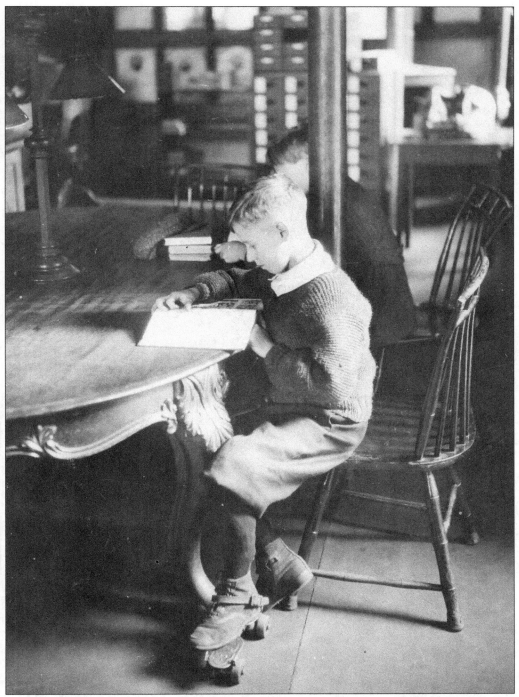

The BPL was the first public library to have a room designed specifically for children. This novel idea removed the library's 3,000 children's books from the closed stacks and shelved them within reach of even the youngest readers. This boy must have been in a great hurry to get to the Children's Room on the second floor because he did not even take the time to remove his roller skates.

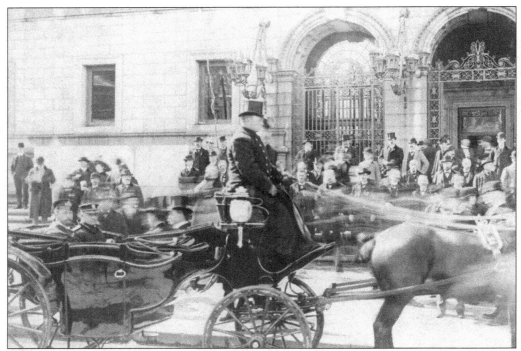

In 1902, Prince Henry of Prussia made his famous trip to America, and on May 24, he visited Boston. Mayor Collins held an official reception for him in Bates Hall. The prince is pictured arriving at the library in his carriage.

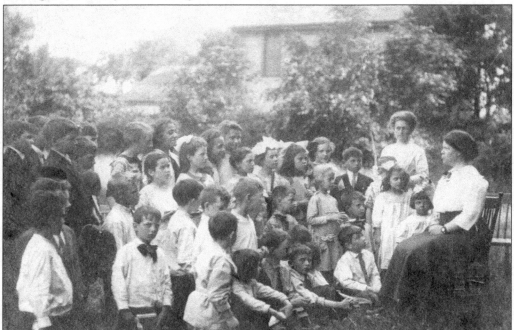

By the time this photograph was taken in 1890, many branches offered story times for children. Here, boys and girls at the Brighton Branch gather outside to listen to the librarian read a story.

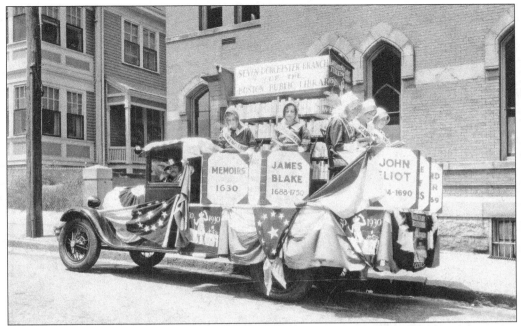

In 1930, Boston celebrated its tercentenary with many festivities and parades. This float commemorates the seven Dorchester branches—Lower Mills, Uphams Corner, Codman Square, Mount Bowdoin, Dorchester, Adams Street, and Mattapan.

At the height of the Great Depression, many families could not spare even a few pennies to pay for their children's overdue books, and soon, the shelves in many branches were empty. Because the library wanted to get the books back, they held a fine-amnesty week in October 1932. This contrite-looking youngster in the North End Branch has just received his receipt for returning his books.

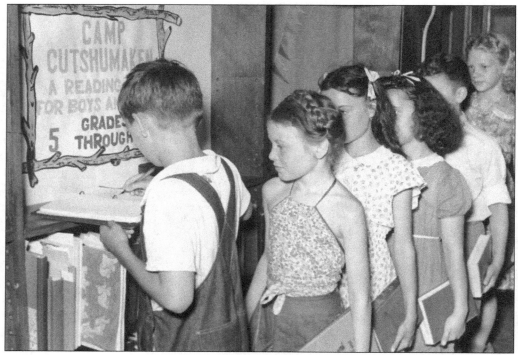

Children are waiting to sign the logbook for Camp Cutshumaken, a summer reading club named after an Indian who lived in Lower Mills in the early days of Dorchester.

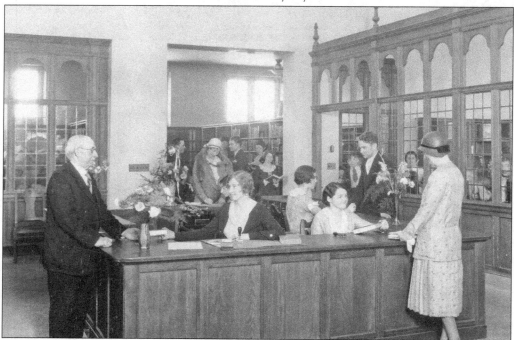

Library staff Anne Sullivan and Alice Waters are sitting at the desk in the center hall of the Parker Hill Branch Library on opening day in 1931.

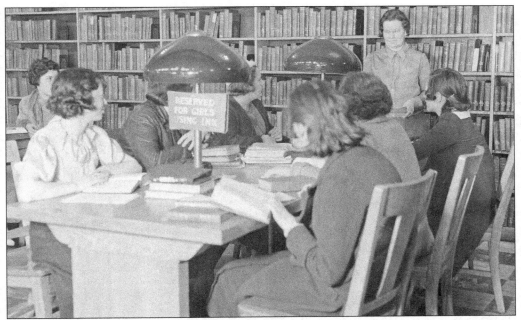

The sign on this study table in the Memorial Branch reads, "Reserved for girls using ink." The sign was supposed to keep the younger children and high school boys away from the high school girls who used the branch as their school library. This branch was located in the Roxbury Memorial High School for Girls.

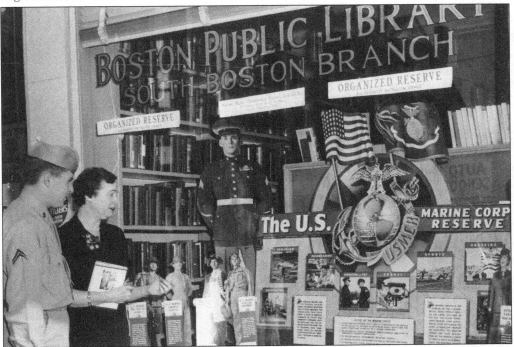

This private first class Marine Corps reservist looks at a window display at the South Boston Branch in 1954.

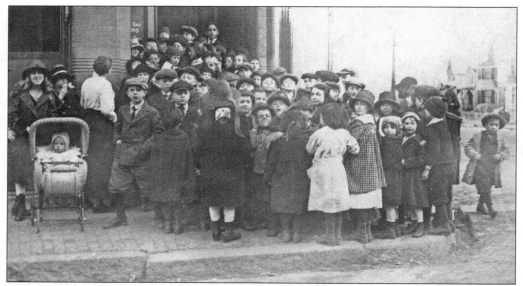

It was common for children to line up outside the Warren Street Reading Room, waiting to be let in for story hour.

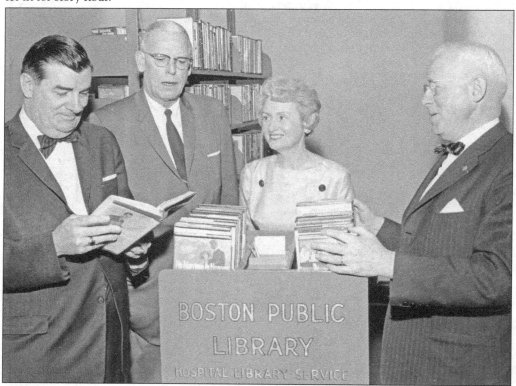

In 1960, the library established service to local hospitals. Looking at some of the selections are, from left to right, William H. Elis (president of the board of trustees, Boston City Hospital), Dr. John F. Conlin (superintendent, Boston City Hospital), Mary G. Langston (hospital librarian), and Milton E. Lord, (director of the Boston Public Library).

The children in this first-grade class from the Nazareth School are enjoying their visit to the South Boston Branch Library in May 1959.

Soon after the Kirstein Business Branch Library was opened in 1930, it became a gathering place for many businessmen from around the city.

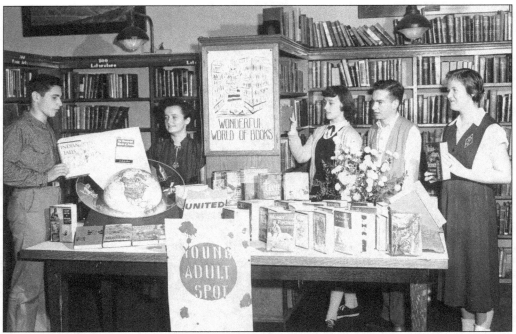

Uphams Corner Delivery Station first opened 1899, and in 1907, the library moved into two floors of the municipal building at 500 Columbia Road. Students are pictured looking at a display of books specifically selected for young adult readers.

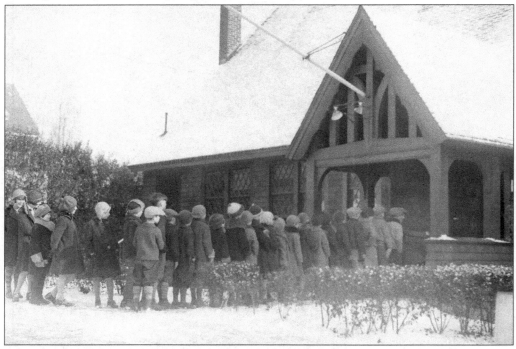

Story time was so popular at the Faneuil Branch Library in 1926 that children waited patiently in a neat line in the cold weather for the doors of the library to open.

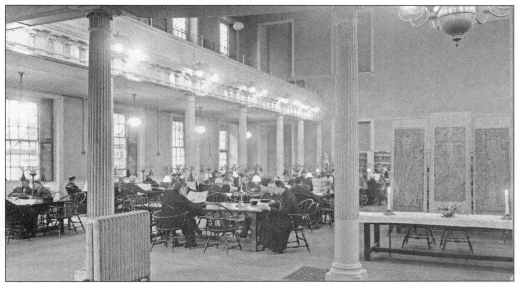

The West End Branch Library opened February 1, 1896, in the Old West Church on the corner of Cambridge and Lynde Streets, with 9,000 books and 80 current periodicals. Once the pews were removed, this large reading area was set up. The three carved wooden panels in the display behind the exhibit table along the right side of this picture are based on a painting by Heywood Sumner titled *The First Christmas*.

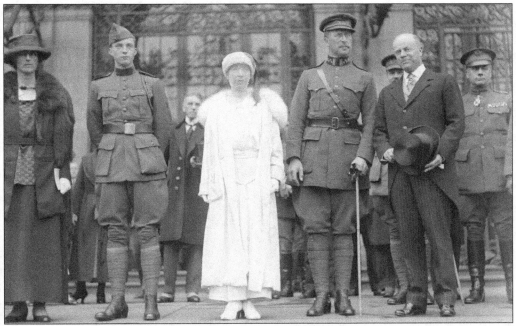

In October 1919, King Albert of Belgium; his wife, Queen Elisabeth; and son Prince Leopold visited the library. The royal family's decision to visit the library was made at the last minute, and only Boston mayor Andrew Peters (far right) accompanied them on their tour of the building. Queen Elisabeth studied the Chavannes murals with great interest and came back to view them several times.

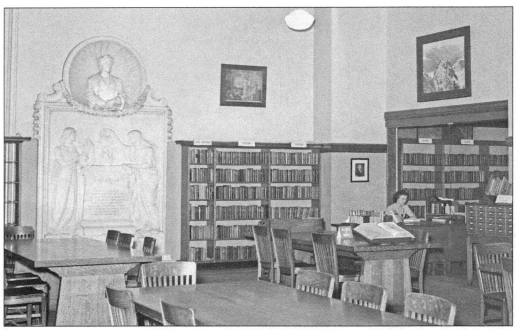

This beautiful white marble bas-relief sculpture of Dante Alighieri was originally donated to the Central Library in 1913, but it was later moved to the North End Branch, where this photograph was taken.

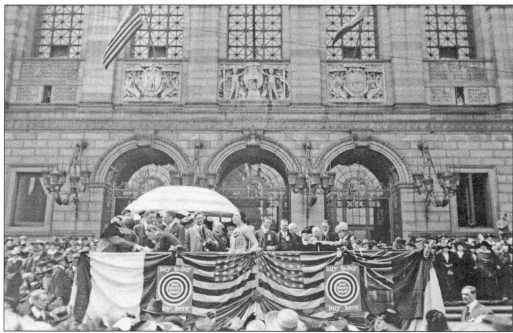

During World War I, Boston held many campaigns encouraging people to purchase liberty bonds. This well-attended assembly was held outside the McKim entrance.

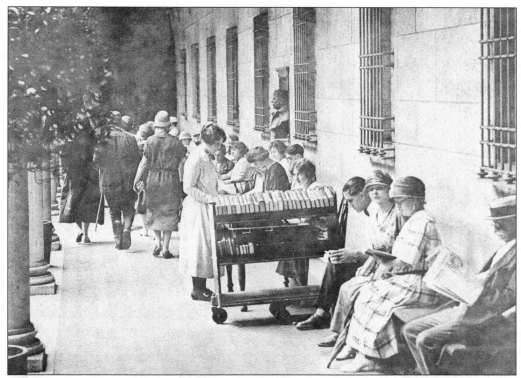

The courtyard has always been a favorite gathering place for people on warm summer days. In the 1920s, new and popular books were displayed on a book truck that was wheeled outside each day (above). Years later, the library expanded on the concept and set up shelves under the protection of a tent, allowing books to be displayed rain or shine (below).

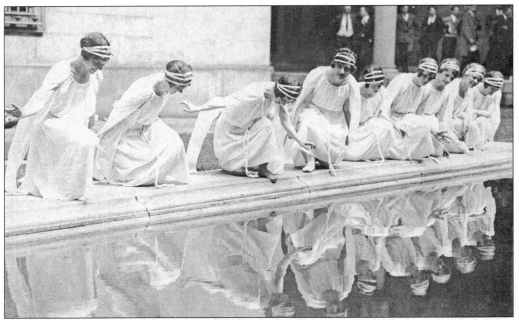

At the turn of the 20th century, *tableaux vivants* (French for "living pictures") were popular forms of entertainment. In this image, students from Simmons College use the courtyard as their stage.

Since 1895, millions of people have walked by Louis Saint-Gaudens's lions, which guard the grand staircase in the McKim building. The more famous pair of lions outside the New York Public Library were created 15 years after the McKim building opened.

Library staff is pictured mending broken spines in books, repairing torn pages, and binding periodicals together in the workroom of the South Boston Branch.

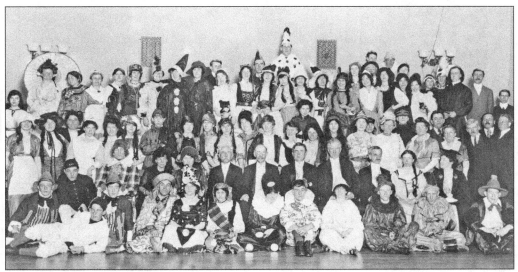

The Boston Public Library Employee Benefit Association held many parties and dances for the staff. On May 20, 1915, employees attended this masquerade party. According to the ticket to the event, the concert ran from 8:00 p.m. to 9:30 p.m., and dancing was held from 9:30 p.m. to 1:00 a.m.

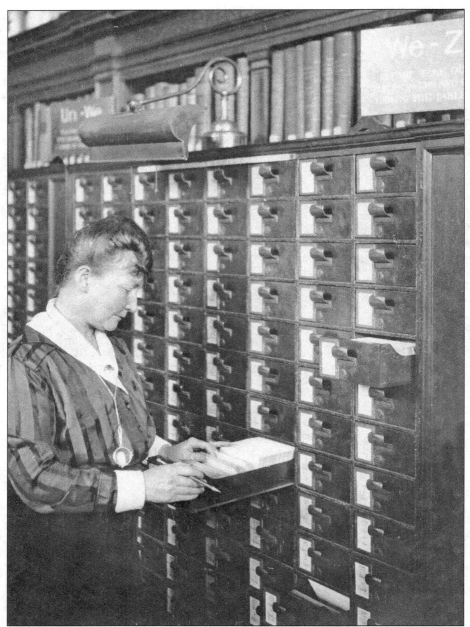

In the early years, the only way for the public to know what the library owned was to refer to printed book catalogs. Since these books were quickly outdated, a new form of catalog was sought, and in 1872, the public card catalog (pictured) was in use. Until 1904, each card was individually handwritten. This public card catalog was not the library's first attempt at a card catalog. Since the 1850s, the staff used an alphabetical card catalog behind the scenes. In addition to a card for each title and author, other cards referenced each word of the title under which a book was likely to be sought. Once again, the library was well ahead of the times; this system is essentially the same as the keyword searches now used in online catalogs. When the card catalog in Bates Hall was closed in 1978, it held over 7.5 million cards.

Four

BRANCHING OUT

THE East Boston Branch Library will be formally opened on Wednesday, March 22d, 1871, at 7 1-2 P. M.

The services will take place at Sumner Hall, and addresses may be expected from the President of the Trustees of the Public Library, and from Rev. W. H. Cudworth, Henry S. Washburn, Esq., H. H. Lincoln, Esq., Hon. Edwd. F. Porter, Nath. Seaver, Esq., Albert Bowker, Esq., and other citizens of East Boston.

You are respectfully invited to be present.

WM. W. GREENOUGH,

ELLIS W. MORTON,

JOSEPH H. BARNES,

Committee upon E. Boston Branch.

JUSTIN WINSOR,
Sec'y Board of Trustees.

The East Boston Branch was the first branch library in the United States. Pictured is an invitation to the opening-day ceremony, held March 22, 1871. Over the years, there have been 58 named branches at 123 different locations.

85

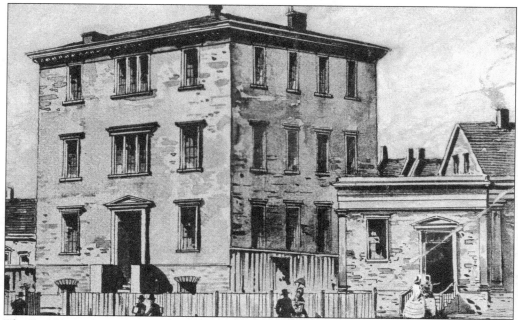

The East Boston Branch opened on the second floor of the old Lyman schoolhouse at 37 Meridian Street on November 28, 1870, and was formally dedicated March 22, 1871. The collection consisted of 5,700 books from the Central Library and also books from the East Boston Library Association and the Sumner Library.

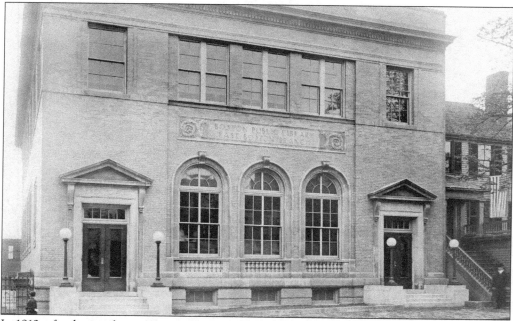

In 1912, after having been 41 years in its first building, the East Boston Branch was moved to the Austin School on Paris Street. Two years later, the present East Boston Branch, at 276 Meridian Street, was opened. Until the Sumner Tunnel was built under Boston Harbor in 1934, this neighborhood was isolated from the city proper, so city services needed to be offered locally.

The South Boston Branch first opened in April 1872 on the second floor of the building at 372 West Broadway, at the corner of E Street. The South Boston Saving Bank leased the first floor, and the Masonic apartments were on the third and fourth floors. It was the second branch library established in the United States. The nucleus of this branch was the library of the Mattapan Literary Association, and it opened with 4,400 volumes. When the building was sold in 1948, the South Boston Branch was closed. In response to high demand for library service, the branch was reopened in June 1950 in a storefront at 385-8 West Broadway, where it remained until destroyed by fire in May 1957. On October 31, 1957, a new building at 646 East Broadway was opened, which consolidated the City Point Branch with the South Boston Branch.

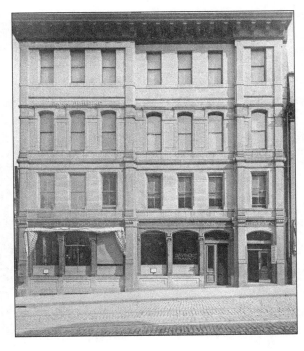

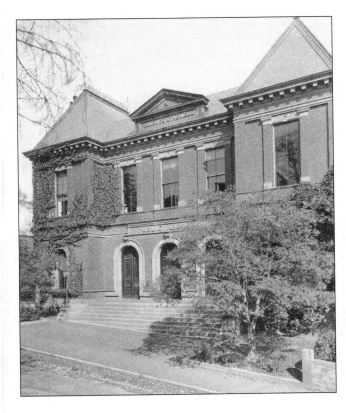

In 1853, Caleb Fellowes bequeathed money for the establishment of an athenaeum in Roxbury. The Fellowes Athenaeum was incorporated in 1866. In an arrangement between the trustees of the Fellowes Athenaeum and the Boston Public Library, it was agreed that the athenaeum would erect the building, and the library would "rent" it as a branch. The rental money was to be spent on books and periodicals. This magnificent three-story building was erected at 46 Millmont Street, at the corner of Lambert Avenue. On July 9, 1873, it officially opened as the Roxbury Branch of the Boston Public Library. When the Dudley Branch Library opened its doors in its current location at 65 Warren Street in April 1978, it replaced both the Roxbury Branch and the Mount Pleasant Branch.

The Blue Hill Avenue Delivery Station first opened April 29, 1892. In 1900, it was renamed the Mount Pleasant Reading Room when it moved into a couple of rooms in this building at Dudley and Magazine Streets.

In 1915, the Mount Pleasant Branch moved into 2,800 square feet on the ground floor of this large municipal building at 12 Vine Street. In 1978, this library and the Roxbury Branch merged to form the Dudley Branch.

The Charlestown Public Library opened in 1862 with a collection of 6,000 books. In 1869, it moved from the Warren Institution for Savings building into more spacious quarters on the second floor in the new city hall building in City Square, where it remained until 1913. When Boston annexed Charlestown in 1874, the library became a branch of the Boston Public Library and contained 15,000 volumes.

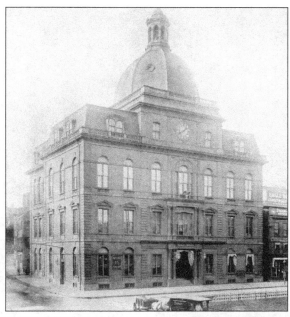

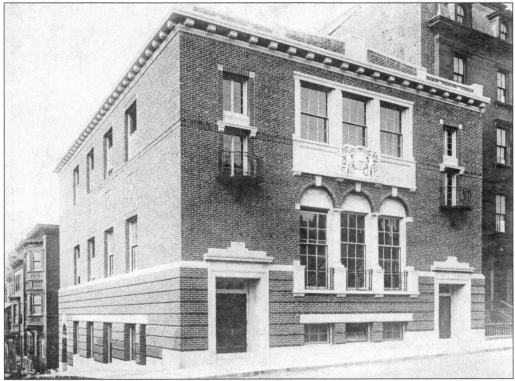

The building pictured opened in 1913, when the Charlestown Branch moved to the corner of Monument Square and Monument Avenue, across from the Bunker Hill Monument. This building had separate reading rooms for adults and children and had a spacious lecture hall. In 1970, the current building at 179 Main Street was opened.

In 1824, the people of Brighton formed the Brighton Social Library, open to local citizens for a fee. A wealthy resident of the area, James Holton, left $6,000 to the town of Brighton to be used for a public library. In 1874, the Holton Library was dedicated, and when the town of Brighton was annexed by the city of Boston later that same year, this building on Academy Hill Road became the Brighton Branch of the Boston Public Library. In 1969, a new Brighton library building was opened on the same site.

On January 25, 1875, the Dorchester Branch was opened to the public on the second floor of this municipal building, located at the corner of Arcadia and Adams Streets. The Dorchester municipal court and a police station were on the third floor of this same building. The criminals who frequented these two institutions caused concern to some parents, who were hesitant to allow their children to walk to the library on their own. In 1969, the current building at 1520 Dorchester Avenue was opened, and the name was changed to Fields Corner.

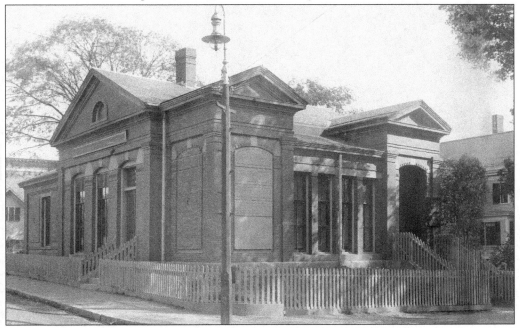

Library service in Lower Mills was first offered in 1875, and in 1883, branch service was moved into the vacated Blue Hills Bank building. Eventually, the collection outgrew that building, and the present Lower Mills Branch Library building was opened in 1981.

Library service in Jamaica Plain began in June 1876 as a small reading room in Curtis Hall. In September, 1877, it expanded and became the first Boston Public Library branch to purchase books from public funds. After a fire in 1908, the library temporarily moved to the second floor of E.W. Clark's dry goods store on Seaverns Avenue.

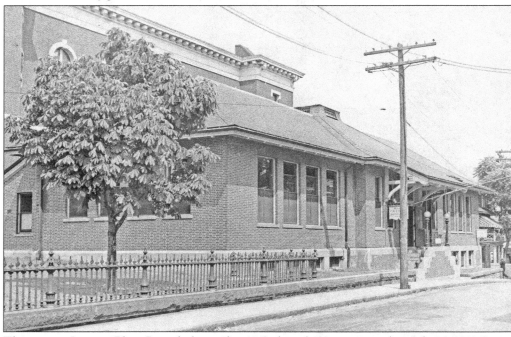

The current Jamaica Plain Branch, located at 12 Sedgwick Street, opened on July 24, 1911. It was built in the distinctive Prairie School style and has large windows and two fireplaces. An addition was built in 1936, and the interior was remodeled in 1963.

In 1877, the Mercantile Library Association made a gift of its library of 18,000 volumes to the Boston Public Library on the condition that part of the collection be used as the nucleus of a branch library in the South End. The branch was located in the Mercantile Library Association until 1879, when it was moved to the basement of English High School on Montgomery Street. In 1904, the branch was relocated to the Every Day Church at 397 Shawmut Avenue (above). It was moved again in 1923, this time to the John J. Williams Municipal building at 65 West Brookline Street (below). On June 7, 1971, the South End Branch Library moved to a new building at its present location at 685 Tremont Street, which was on the site of the original Mercantile building.

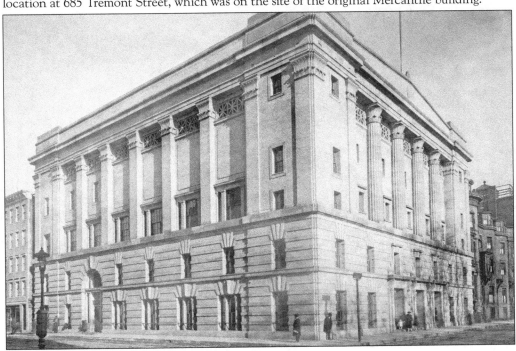

The first step toward establishing a library in Roslindale was taken in 1878, when a delivery station for materials from the Jamaica Plain Branch was opened on Florence Street at the corner of Ashland Street (above). In 1898, the book delivery station was moved to a drugstore at the corner of Washington and Ashland Streets. In 1900, the library was moved to the Old Taft's Tavern building. In 1918, the Roslindale Branch was located below a gymnasium in the municipal building at 4220 Washington Street (below). Until it moved 43 years later, the patrons rarely had a quiet moment. In 1961, a new semicircular building was opened at 4238 Washington Street in Roslindale.

The collection of the Spring Street Social Library was given to the Boston Public Library in 1876 and was used to create the West Roxbury Delivery Station. The building on Centre Street near Mount Vernon Street was opened in January 1880 (above). In 1896, it became a full branch of the Boston Public Library. In 1922, a new library building was constructed at 1961 Centre Street (below). In 1977, a fire destroyed the neighboring church, and the land was deeded to the library on the condition that they use it to build an addition. In 1989, the new wing was opened to the public.

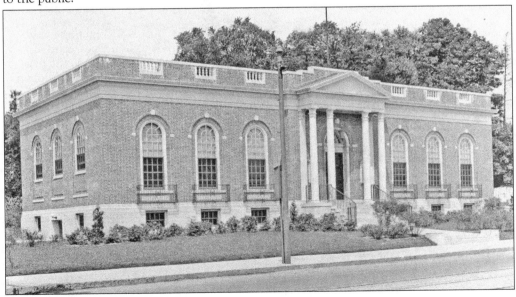

Library service began in Mattapan in 1881 when a delivery station opened in the Oakland Hall building. In 1898, the book collection consisted of 98 volumes. The library was granted branch status in 1923, and in June 1931, the Mattapan Branch (pictured) opened at 10 Hazelton Street. On February 28, 2009, the new building at 1350 Blue Hill Avenue opened.

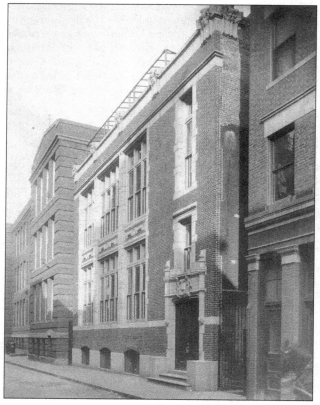

The first North End Branch was opened in October 1882 in two large rooms on the first floor of the Hancock School on Parmenter Street. On November 1, 1886, the branch moved to the corner of North Bennett and Salem Streets. The building seen here, located at 3a North Bennet Street, was previously the Portuguese Church of St. John the Baptist, and in 1913, it opened as the North End Branch. For a time, the branch was unique in having a roof garden, which was used as a reading room in the summer. In 1965, the library moved to its present building at 25 Parmenter Street.

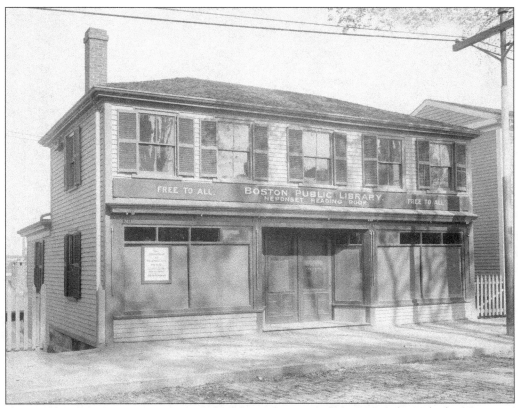

Service to the Adams Street neighborhood was first provided in 1875 through the Neponset Delivery Station on Walnut Street. In 1907, the Neponset Reading Room (above) was opened at 362 Neponset Avenue. In 1924, it became a branch library, and in 1951, it was renamed the Adams Street Branch when it moved to 690 Adams Street (below).

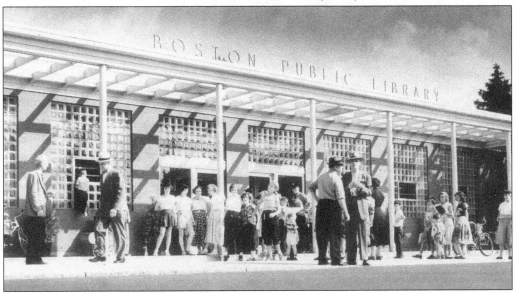

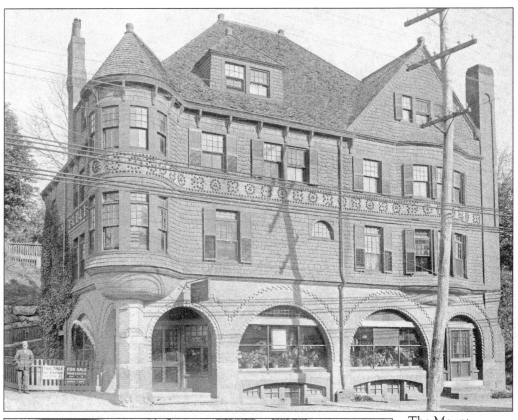

The Mount Bowdoin Reading Room was opened on November 1, 1886, in this Victorian-style commercial building at the corner of Washington Street and Eldon Street (above). In 1930, it became a branch when it moved to 275 Washington Street (left). The branch closed on December 11, 1970.

The Allston Delivery Station was opened in 1889 and was located in a drugstore at 26 Franklin Street. In 1905, a reading room at 354 Cambridge Street (above) replaced the delivery station, and in 1924, it became a branch. The library moved to 161 Harvard Avenue in 1929 (below). In 1981, amid statewide budget cuts, the old Allston Branch was closed. However, it reopened in a new building on June 16, 2001, at 300 North Harvard Street. In 2003, the branch was renamed the Honan-Allston Branch.

In 1890, the Dorchester Station Reading Room was opened at 1 Milton Avenue. After a short time in a building at 157 Norfolk, it moved into this municipal building at 6 Norfolk Street in 1905. It was renamed Codman Square after a local preacher and patriot. On November 1, 1914, it became a full branch library. In 1978, it moved to its present location at 690 Washington in Dorchester.

In 1896, the Harrison Street Delivery Station opened at 202a Harrison Street. In 1916, it became the Tyler Street Delivery Station when it moved into the first floor of this commercial building at 130 Tyler Street. In 1924, it became a branch, but it was closed in 1938. Tyler Street reopened as a reading room in December 1951, but it closed again only four and a half years later, in June 1956.

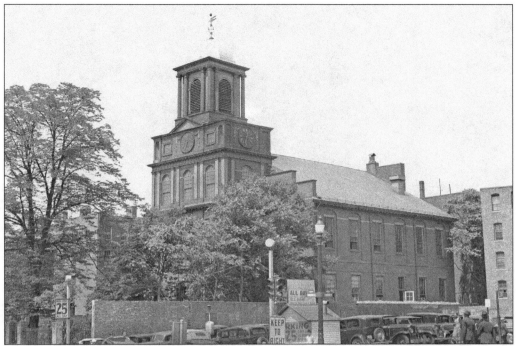

At the corner of Cambridge and Lynde Streets stands the Old West Church, originally built in 1806. In 1894, the property was purchased by the City of Boston. The extensive remodeling carefully preserved its original architectural character, and in 1896, the new West End Branch opened. The balcony of the church was changed into the Children's Room, and the nave became the main reading room, which would accommodate 250 people. The library is pictured before urban renewal destroyed the old West End neighborhood.

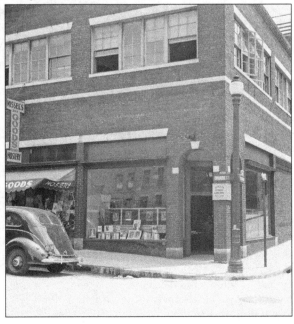

Boston's urban renewal in the 1960s resulted in the West End neighborhood being almost totally leveled. The historic Old West Church was scheduled for demolition, but before it was destroyed, it got a last minute reprieve and dodged the wrecking ball. But by April 15, 1960, the branch had already moved into this temporary location in a commercial building on the corner of Cambridge and Joy Streets while the new structure at 151 Cambridge Street was being constructed. The new building opened in February 1968.

In 1896, the Dudley Street Delivery Station opened in a storefront at 752 Dudley Street. In 1904, when it moved into the two-year-old municipal building on Columbia Road at the corner of Bird Street, it changed its name to Uphams Corner Reading Room. After rapid growth, it officially became a branch library in 1907. At first, it occupied only one large room, but later, the Children's Room expanded into another room. There was a swimming pool and public baths on the ground floor, but when leaks developed, they fell into disuse, and the Children's Room took occupancy in this space. The library was renovated in 1989, but many residents still recall the gymnasium, swimming pool, and public showers of their childhood.

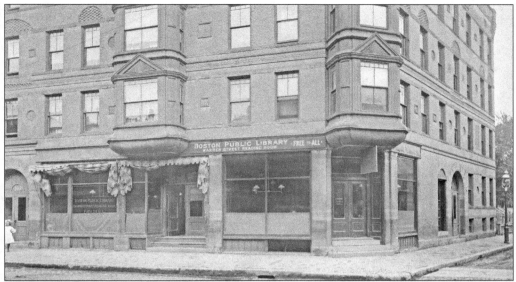

The Warren Street Reading Room was opened on May 1, 1896, on the ground floor of a storefront at 329 Warren Street. In 1905, it moved down the road to 390 Warren Street, and nine years later, it expanded into an adjacent store with 2,521 square feet of space (above). In 1919, the trustees decided to confer upon the reading room the dignity of being a branch. In 1926, the Warren Street Branch moved into two floors of the Roxbury Memorial High School for Girls, located at the corner of Warren Street and Crawford Street, where it was renamed the Memorial Branch Library (below). In December 1970, the name was changed again to the Grove Hall Branch and moved to the corner of Warren and Crawford Streets. On April 4, 2009, a beautiful new library opened in the newly renovated Jeremiah E. Burke High School at 41 Geneva Avenue in Dorchester.

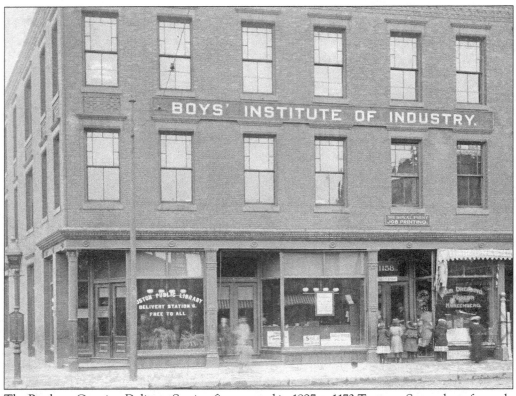

The Roxbury Crossing Delivery Station first opened in 1897 at 1173 Tremont Street, but after only three years, it moved to the first floor of the Boys' Institute of Industry building at 1154 Tremont Street (above). In 1921, it became a reading room and moved to 208 Ruggles Street (below). It was closed July 1, 1938.

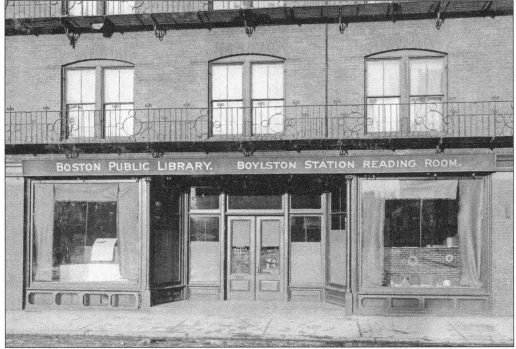

The Boylston Station Reading Room (above) was opened in November 1897 at 160 Lamartine Street. In 1924, it became a branch library. The white limestone, Jacobean-style building at 433 Centre Street in Jamaica Plain was opened in 1932 (below). In December 1940, the name of the branch was officially changed to the Monsignor Arthur T. Connolly Branch, a tribute to a longtime member of the Boston Public Library Board of Trustees.

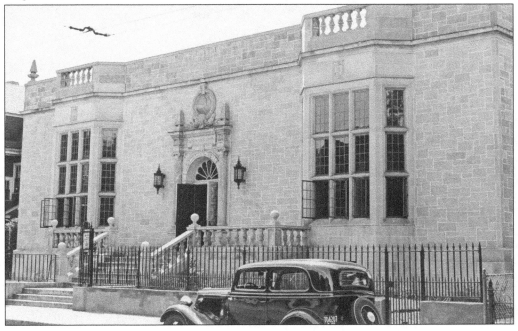

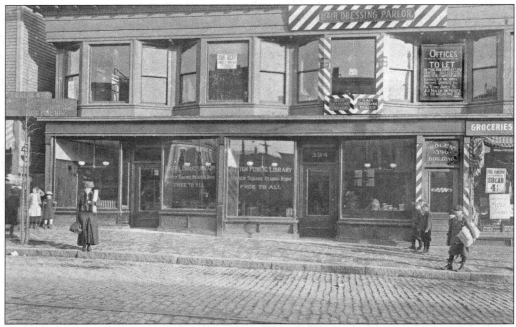

In 1901, the Andrew Square Reading Room opened in the John A. Andrew schoolhouse on Dorchester Street. It temporarily closed in 1905 and then reopened at 396 Dorchester Street in 1914 (above). It became a branch in 1924, and in 1931, it moved to 394 Dorchester Street (below). In 1940, it changed its name to Washington Village, and in 1942, it was moved to 290 Old Colony Avenue. It closed due to a fire in August 1972, and it was not until 1983 that it reopened in two apartments in the Old Colony housing development.

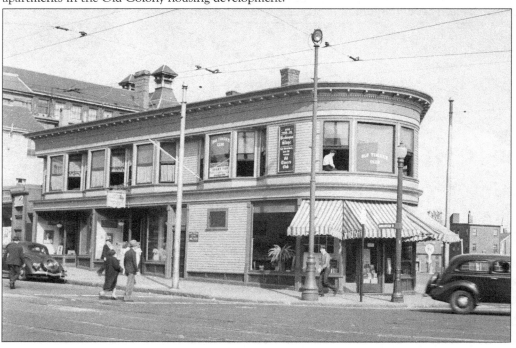

The Orient Heights Branch Library opened in 1912 in this building at 5 Butler Street in East Boston. After a fire damaged the building in 1982, the library was reopened at 18 Barnes Avenue.

In 1903, the North Street Reading Room opened in this storefront at 207 North Street. It closed in 1911.

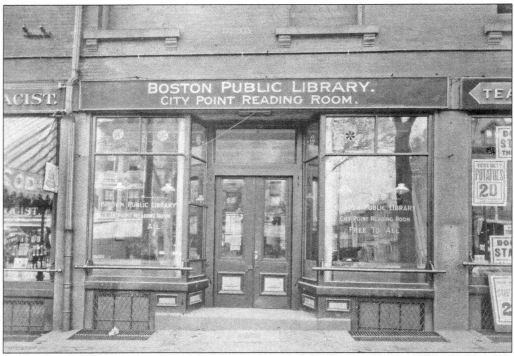

The City Point Reading Room was opened in a storefront at 615 Broadway on July 18, 1906 (above). In 1914, its small quarters outgrown, it was moved into 678 square feet of space on the second floor of this South Boston municipal building at 533 Broadway (below). This library closed in 1957, when it was consolidated with the South Boston Branch Library.

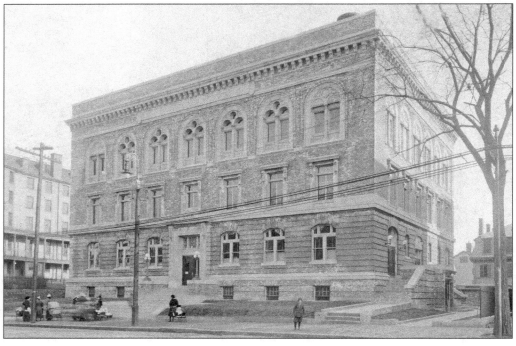

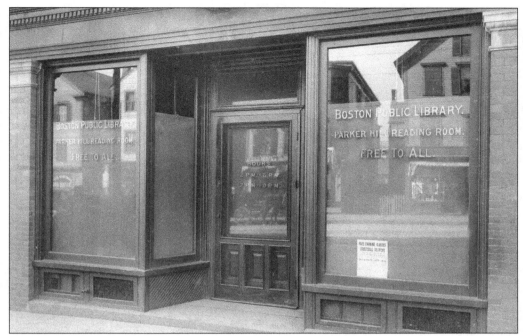

The Parker Hill Reading Room was opened in a tiny storefront at 1518 Tremont Street in July 1907 (above). In 1924, it became a branch, and the library moved to its present quarters at 1497 Tremont Street in Roxbury in 1931 (below). This two-story Gothic building was designed by Ralph Adams Cram. It is open and airy and has many lovely details, such as the carved seal of the Boston Public Library above the front door.

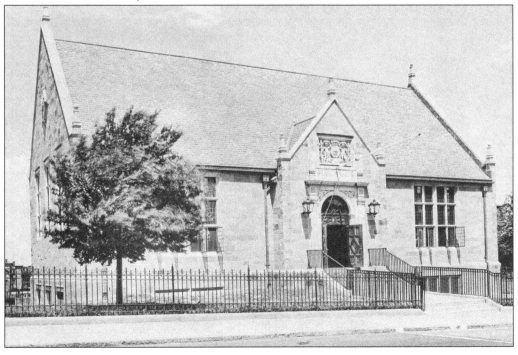

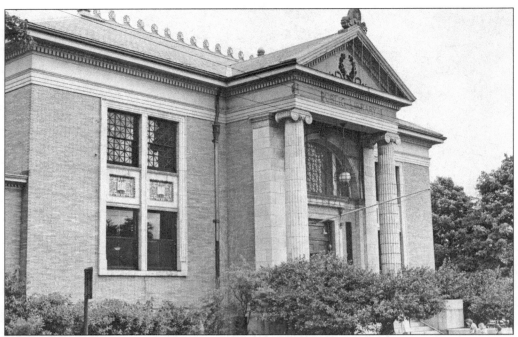

The town of Hyde Park opened its first library in the Cobb's block of Everett Square in 1873. In 1884, it moved to larger quarters in the Masonic block at the corner of Harvard Avenue and River Street. Ground was broken for the town library in December 1898, and this magnificent building at 35 Harvard Avenue was opened in September 1899. It became a branch of the Boston Public Library when the town joined the city of Boston in 1912. This photograph was taken prior to 1997, when a new addition doubled the size of the building.

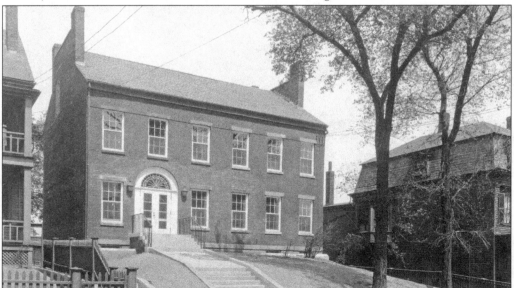

In 1921, the Jeffries Point Reading Room opened at 195 Webster Street in East Boston. It became a branch in 1924 and then moved to this building at 222 Webster Street in 1932. The branch closed in June 1956.

The Faneuil Delivery Station opened in 1914 in a small, homey wooden building at 100 Brooks Street (above) and became a branch in 1924. In 1931, the library moved to the Art Deco building located at 419 Faneuil Street in Oak Square in Brighton (below).

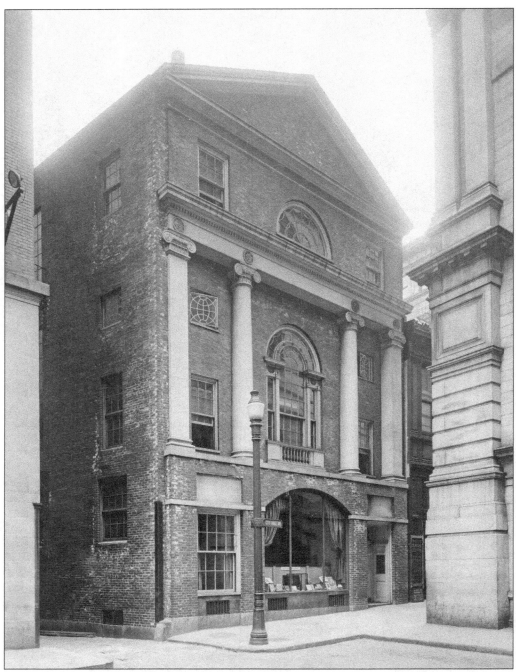

Kirstein Business Branch opened in 1930 at 20 City Hall Avenue on the site of an abandoned police station. The Bulfinch-style building had four floors with 4,600 square feet of public space. In 2009, the library moved to the Central Library, where it now occupies a larger space on a single floor. Kirstein was the second public business library in the United States, and its unique collection directly effects the financial and economic health of the city. Louis Kirstein donated the building to the library as a memorial to his father, Edward Kirstein.

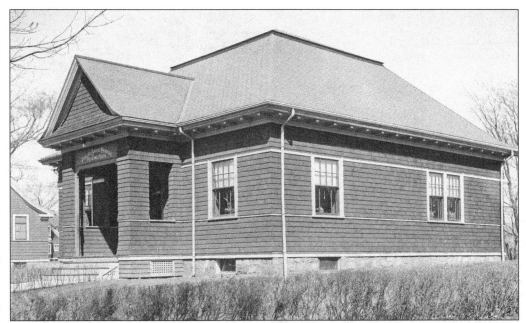

A delivery station in Readville was opened in 1896 on property owned by the Blue Hill Evangelical Society. It was closed in 1924 and reopened as the Phillips Brooks Memorial Branch in 1931 in this bungalow-style building at 12 Hamilton Street. The Rev. Phillips Brooks was the author of the Christmas carol "O Little Town of Bethlehem." The land on which the building was located was used during the Civil War as a training camp for soldiers (Camp Meigs). The branch closed in 1956.

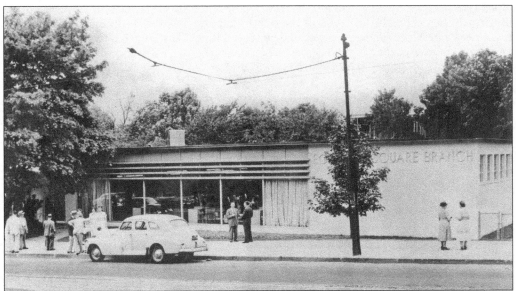

In July 1953, the Egleston Square Branch opened at 2044 Columbus Avenue in Roxbury. Recently, teens from the mayor's Boston Youth Fund painted a beautiful mural on the side of the building, and with the help of the Boston Public School's City Roots program, the Friends of the Library helped beautify the building by enhancing the landscaping.

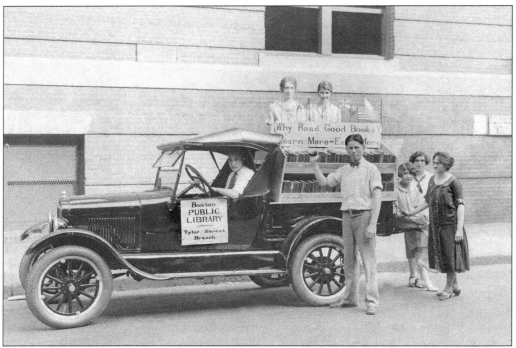

In 1926, the Tyler Street Branch created the Book Wagon (above). About 200 books were placed on open shelves in the back of a small pick-up truck. Because of the demographics of the neighborhood, this wagon also included a section of books in Hebrew. The young man in this picture is ringing a hand bell that called the neighbors to the truck. The sign reads, "Why Read Good Books? Learn More, Earn More." In fact, this was not the first attempt to bring the books directly to the people. In July 1925 in the South End, the Tyler Street Branch began using a two-wheeled pushcart similar to those used by vegetable peddlers. In February 1950, the library launched a more modern bookmobile (below).

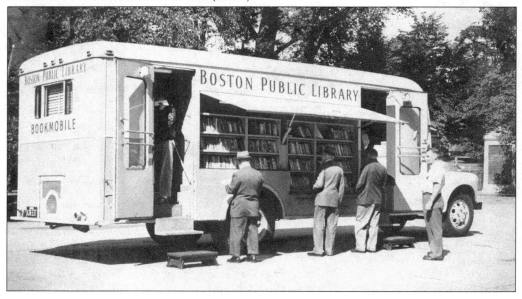

Five

TREASURES

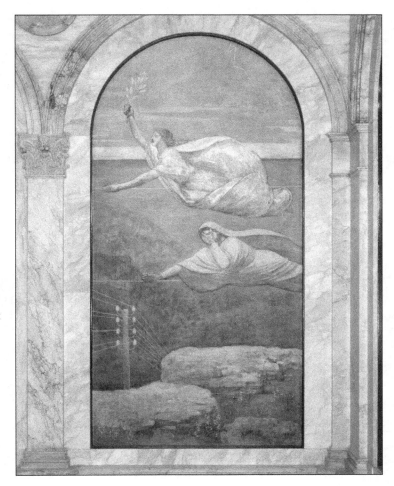

The murals in the main staircase of the McKim building were created by France's greatest master muralist of the day, Pierre Puvis de Chavannes. Although they appear classical in nature, upon closer inspection, interesting modern details can be found. This panel, titled *Physics*, includes a telegraph pole in the lower left section.

THE
LIFE
OF
GEORGE WASHINGTON,
COMMANDER IN CHIEF
OF THE
AMERICAN FORCES,
DURING THE WAR WHICH ESTABLISHED THE INDEPENDENCE
OF HIS COUNTRY,
AND
FIRST PRESIDENT
OF THE
UNITED STATES.
COMPILED
UNDER THE INSPECTION OF
THE HONOURABLE BUSHROD WASHINGTON,
FROM
ORIGINAL PAPERS
BEQUEATHED TO HIM BY HIS DECEASED RELATIVE, AND NOW IN POSSESSION
OF THE AUTHOR.
TO WHICH IS PREFIXED,
AN INTRODUCTION,
CONTAINING
A COMPENDIOUS VIEW OF THE COLONIES PLANTED BY THE ENGLISH
ON THE
CONTINENT OF NORTH AMERICA,
FROM THEIR SETTLEMENT
TO THE COMMENCEMENT OF THAT WAR WHICH TERMINATED IN THEIR
INDEPENDENCE.

BY JOHN MARSHALL.

VOL. V.

PHILADELPHIA:
PRINTED AND PUBLISHED BY C. P. WAYNE.

1807.

Pres. John Adams assembled one of the greatest private libraries in early America. His extraordinary collection is now housed at the Boston Public Library and totals more than 3,700 volumes, 250 of which were annotated with Adams's personal notes, comments, and references to his contemporaries. Chief Justice John Marshall, the author of the book pictured, inscribed and presented it to Adams.

This gold medal was presented to then general George Washington by the Second Continental Congress in commemoration of the evacuation of Boston by the British troops on March 17, 1776. It was purchased in March 1876 from the heirs of Washington's older brother by Robert C. Winthrop and 49 other Boston citizens and then given to the city to be preserved in the library. This was the first Congressional Gold Medal ever awarded. It measures 2.6875 inches in diameter.

John Adams used Paul Revere's original drawing of the Boston Massacre when he successfully defended the British troops at their trial for murder. If one looks closely, it is shown exactly where the bodies laid after being shot.

This first collected edition of the work of William Shakespeare appeared seven years after his death in 1616 and is known as the *First Folio*. Long considered the most important publication in English literature, the *First Folio* contains 36 plays and is the sole authority for texts of 12 of Shakespeare's plays, including *The Tempest*, *Macbeth*, *Twelfth Night*, and *Julius Caesar*. It is believed that around 1,000 copies were printed, and according to the most recent census, only 228 are still in existence. The library owns one of the few extant perfect copies, which was acquired in 1873.

In 1455, Johannes Gutenberg, a German goldsmith and printer, produced the first book printed using moveable type on a mechanical press—the Gutenberg Bible. In 1921, a New York book dealer broke up his incomplete copy and sold each leaf separately in a black leather binding under the title *A Noble Fragment*. The library owns the leaf that contains Exodus xiv: 27–xvi: 22.

The first 37 measures of this autographed manuscript of *Fugue for 3 Strings* are in the hand of Wolfgang Amadeus Mozart. This work for violin, viola, and cello was completed by Abbe Maximilian Stadler, and the handwriting in the margin indicates that the instrumentation was done at a later date. The work dates from the early 1780s.

This richly illuminated manuscript, titled *Psalterium cum Antiphonis*, was created over 530 years ago in a Benedictine monastery in Lombardy, Italy. The pages are made from vellum, and it is bound in heavy wooden boards with metal corner pieces and clasp. The book has 210 leaves and is very large (24 inches high) because it was intended to be placed on a tall lectern and read from a distance by choirs.

A large scrapbook of materials relating to the life and magical career of Harry Houdini was compiled by his friend and admirer Quincy Kilby between 1904 and 1926. One of the letters in the scrapbook is a 1915 challenge from the James Hanley Brewing Company to Harry Houdini. The letter reads in part, "We hereby challenge you to escape from a large cask after we have filled the same with our famous 'Half Stock Ale' and our men have locked you in the case." Houdini scrawled across the bottom "I accepted & escaped (and I do not drink)."

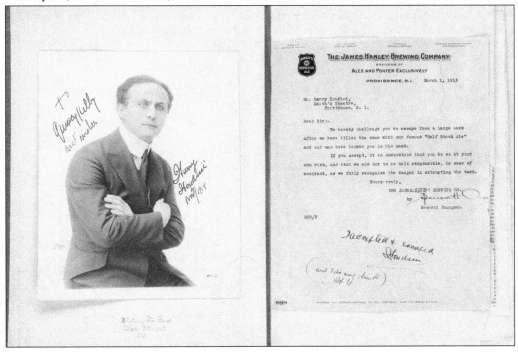

Phillis Wheatley was only eight years old when she was sold as a slave to a Boston family in 1761. Although she was a servant, she was tutored by her owners and was the first African American woman in the country to have her poetry published. The library owns a signed copy of her book *Poems on Various Subjects, Religious and Moral*, which was published in 1773.

American poet, essayist, journalist, and humanist Walt Whitman is among the most influential American poets and is often called the father of free verse. This is the original manuscript of Whitman's *To a Locomotive in Winter*, a poem included in his 1876 edition of *Leaves of Grass*. The two manuscript pages, dated February 23, 1874, are covered with his extensive corrections, edits, pasted paper overlays, and insertions.

This ornately decorated map of the world, created by Gerard Valck, was first issued about 1695 and is titled *Novus Planiglobii Terrestris Per Utrumque Polum Conspectus*. This polar-oriented projection was included in atlases published during the early 1700s. The map is beautifully hand colored and is decorated with the sun and the moon and vignettes of the biblical story of creation.

Many famous statues and busts are scattered throughout the McKim building. One of the author's favorite statues is this beautiful white marble one, *Child and a Swan*, created by Leopoldo Ansiglione. It is about three feet high and originally sat outside the Children's Room in the McKim building. It was donated to the library in 1917 by Mary F. Bartlett. (Photograph by Catherine Willis.)

Sacco and Vanzetti were two Italian-born laborers and anarchists who were executed on August 23, 1927, for the 1920 armed robbery and murder of a pay clerk and security guard in South Braintree, Massachusetts. This plaster death mask of Vanzetti was prepared immediately after his execution by electrocution and is a curious part of the large Sacco and Vanzetti Collection, which also includes photographs, defense papers, and a crematory containing a portion of the men's commingled ashes.

This is a leaf from a 15th-century antiphonary for the *Mass of Christmas Eve*. The manuscript is handwritten and includes a beautiful miniature painting of an angel and three shepherds within the letter D. Possibly, three or more artists worked on this one page. A scribe copied the Latin text and the musical notes, an illuminator applied the gold to enrich and illuminate the page, and an artist painted the beautiful scene of the angel alerting the shepherds to the birth of Jesus Christ as they tended their flocks outside the gates of a medieval town. The Boston Public Library is home to several hundred medieval manuscripts.

The Whole Booke of Psalmes, commonly known as the *Bay Psalm Book,* was the first book written and printed in the American colonies in 1640. While there was an initial press run of approximately 1,700 copies, only 11 are now known to exist. Two copies are owned by the Boston Public Library. The last publicly traded copy of the *Bay Psalm Book* sold in 1947 to Yale University for $151,000, then the highest price ever paid for a printed book.

This broadside, dated May 26, 1854, protested the kidnapping of a slave and also announced a public meeting at Faneuil Hall. Home of abolitionist William Lloyd Garrison, Boston had become known worldwide as the center of the American abolition movement. The Boston Public Library is home to one of the largest collections of antislavery materials in the country, totaling over 21,000 books, original manuscripts, and artifacts relating to the abolitionist movement.

123

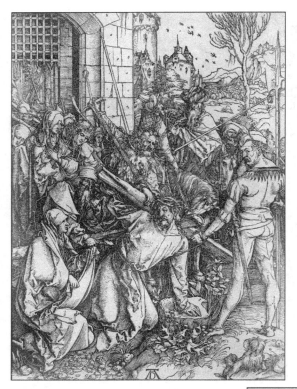

A prolific painter, printmaker, engraver, and woodcut artist, Albrecht Dürer established his reputation across Europe while he was still in his 20s. This original woodcut, titled *Christ Carrying the Cross*, is from the *Large Passion* series and was created between 1498 and 1499.

The McKim building itself is a treasure. It was added to the National Register of Historic Places in 1973 and became a National Historic Landmark in 1986. Eventually, it began to show its age, and starting in 1991, selected areas began to be renovated. On this section of the wall across from the Map Room Café, one can see the contrast between the cleaned wall and a small section that was left uncleaned. When the library first opened, the steam generated by the three coal-fed boilers powered the engines and dynamos that in turn furnished much of the electrical power to the library. Each year, the library required about 1,450 tons of coal to heat these boilers, the residue of which greatly contributed to the grime. (Photograph by Catherine Willis.)

HEAD LIBRARIANS

Over the years, the title of the head librarian has been librarian, superintendent, director, director and librarian, or president. Here is a list of these leaders:

1852–1858	Edward Capen	Librarian
1858–1868	Charles Coffin Jewett	Superintendent
1868–1877	Justin Winsor *	Superintendent
1877–1878	Samuel A. B. Green *	Librarian (Acting)
1878–1890	Mellen Chamberlain	Librarian
1892–1894	Theodore Frelinghuysen Dwight	Librarian
1895–1899	Herbert Putnam *	Librarian
1899–1903	James Lyman Whitney	Librarian
1903–1917	Horace Greeley Wadlin	Librarian
1917–1931	Charles Francis Dorr Belden *	Director
1932–1965	Milton Edward Lord *	Director and Librarian
1965–1983	Philip J. McNiff	Director and Librarian
1983–1985	Liam M. Kelly	Director (Acting)
1985–1996	Arthur Curley *	Director and Librarian
1997–2008	Bernard Margolis	President
2008–2008	Ruth Kowal	President (Acting)
2008–	Amy E. Ryan	President

*Also elected president of American Library Association (ALA)

BIBLIOGRAPHY

Bacon, Edwin M. *King's Dictionary of Boston*. Cambridge, MA, 1883.

Benton, Josiah H. *The Working of the Boston Public Library*. Boston: Rockwell and Churchill Press, 1914.

Boston Public Library. *BPL News*, vol.16, no. 6 (Summer, 1965).

Boston Public Library Trustees. *Annual Report of the Boston Public Library*. Boston: Boston Public Library, 1853–1992.

Boston Public Library Trustees. *Boston Public Library Documentary History, 1848–1875*, 4 vols.

Boston Public Library Trustees. *The Boston Public Library: Its System of Branch Libraries, a Brief Description*. Boston: Boston Public Library, 1941.

Boston Public Library Trustees. *Building a Great Future Upon a Glorious Past*. Boston: Centennial Commission of the Boston Public Library, 1952.

Boston Public Library Trustees. *Evolution of a Catalog: From Folio to Fiche: Report on the Research Library Catalogue Project*. Boston: Boston Public Library, 1981.

Boston Public Library Trustees. *Hand-book for Readers of the Boston Public Library, Containing the Regulations of the Library*. Boston: Bookwell and Churchill, 1883.

Boston Public Library Trustees. *McKim Building Art and Architecture Correspondence*.

Boston Public Library Trustees. *A New Handbook of the Boston Public Library and its Mural Decorations*. Boston: Boston Public Library Employees Benefit Assoc., 1918.

Boston Public Library Trustees. *Proceedings of the Dedication of the Building for the Public Library of the City of Boston*. Boston: Boston City Council, 1858.

McCord, David. *. . . as Built with Second Thoughts, Reforming What Was Old!: Reflections on the Centennial Anniversary of the Boston Public Library*. Boston: Centennial Commission of the Boston Public Library, 1953.

Wadlin, Horace G. *The Public Library of the City of Boston: A History*. Boston: Trustees of the Library, 1911.

Whitehill, Walter Muir. *Boston Public Library: A Centennial History*. Cambridge, MA: Harvard University Press, 1956.

Wick, Peter Arms. *A Handbook to the Art and Architecture of the Boston Public Library*. Boston: Associates of the Boston Public Library, 1977.

ABOUT THE BOSTON PUBLIC LIBRARY TODAY

The Boston Public Library is one of the premier libraries of the world. Over 358,500 Boston residents have library cards, and the library owns a historically significant collection of 22,350,750 books, videos, sound recordings, manuscripts, pamphlets, photographs, drawings, maps, musical scores, and many other rare and valuable items. Some of the programs and public services that the library provides include:

The library's website, www.bpl.org, receives over 7.7 million visits every year.

The library has digitized over 25,000 out-of-copyright books and provides access to each of them 24 hours a day, seven days a week, through the Internet Archive at www.archive.org.

The library's Flickr page, which includes over 16,000 images, has had over 1.6 million visitors.

Patrons annually download over 150,000 popular audiobooks, e-books, music, and video at no charge.

Thousands of electronic databases, historical newspapers, and back issues of periodicals are available online.

The Norman B. Leventhal Map Center has a collection of 350,000 historically significant maps, in print and online.

The library regularly offers authors an opportunity to read passages from their books and to talk about how they created them.

The library has many resources for genealogical research and a regular Local and Family History lecture series.

Award-winning exhibitions continuously highlight the treasures of the Boston Public Library.

The Homework Assistance Program delivered more than 20,000 in-person tutoring and mentoring sessions.

The library is a Government Documents depository and collects print and online materials from federal, state, and local governments.

The Lowell Lecture series, established in 1836, is generously sponsored by the Lowell Institute and makes great ideas accessible to all people, free of charge.

The Never Too Late Group is one of the country's oldest, continuously running groups for seniors.

The Boston Public Library serves as a key partner and venue for the annual Boston Book Festival in Copley Square.

Books are just the beginning!

Visit us at
arcadiapublishing.com

CPSIA information can be obtained
at www.ICGtesting.com
Printed in the USA
LVHW100314241219
641443LV00028B/1253/P

9 781531 649524